SPIRIT AND VISION
IMAGES OF RANCHOS DE TAOS CHURCH

Spirit and Vision

IMAGES OF RANCHOS DE TAOS CHURCH

Foreword by
George Kubler

Essays by
Sandra D'Emilio and Suzan Campbell
John L. Kessell

The Museum of New Mexico Press
Santa Fe

*To the parishioners and artists of
Ranchos de Taos Church*

Manufactured in Japan by Dai Nippon
Printing Co., Ltd.

Typography by Business Graphics, Inc.,
Albuquerque, N.M.

Designed by Webb Design Studio, Taos, N.M.

**Library of Congress Cataloging-in-
Publication Data**

D'Emilio, Sandra, 1939–
 Spirit and vision.

 Bibliography: p.
 Includes index.
 1. Art, American. 2. Art, Modern—20th
century—United States. 3. San Francisco de
Asis Church (Ranches of Taos, N.M.) in art.
4. Taos Society of Artists. I. Campbell, Suzan.
II. Kessell, John L. III. Title.
N6512.5.T34D4 1987 760'.0444'0973 87-1736
ISBN 0–89013–169–4 (clothbound)
ISBN 0–89013–170–8 (paperbound)

Museum of New Mexico Press
P.O. Box 2087
Santa Fe, New Mexico 87503

CONTENTS

LIST OF PLATES

All dimensions are given height preceding width.

PLATE 31
Robert Lougheed (1910–1982)
Ranchos de Taos Mission 1971
oil
7⅜" × 9½"
Collection of Mr. and Mrs. George Carlson,
Elizabeth, Colorado

PLATE 32
Helen Greene Blumenschein (1909–)
Ranchos Church ca. 1970
oil
23⅜" × 29¹⁄₁₆"
Collection of the artist

PLATE 33
Andrew Dasburg (1887–1979)
Spring in Ranchos 1974
pastel
17½" × 23"
Collection of Dr. Richard and Susan Streeper,
Santa Fe

PLATE 34
Morris Rippel (1930–)
Ranchos de Taos 1974
watercolor
14½" × 23"
Collection of Mr. and Mrs. Bennet L. Price,
Colorado

PLATE 35
Alex Sweetman (1946–)
Ranchos de Taos Church, Westside negative
1972, print 1982
gelatin silver photograph with spray paint
60" × 20"/ 60" × 20"/60" × 20"
Collection of the artist

PLATE 36
Harold Joe Waldrum (1934–)
Primrose Light 1972
acrylic
72" × 72"
Collection of the artist

PLATE 37
Allen E. Carter (1933–)
*Church, Ranchos de Taos–Sunrise #1,
#2, #3* 1975
gelatin silver photograph
13¼" × 10½"
Collection of the Museum of Fine Arts,
Museum of New Mexico, Santa Fe
Gift of the artist

PLATE 38
Lynn Lown (1947–)
Untitled 1976
gelatin silver photograph
15¼" × 15¼"
Collection of the artist

PLATE 39
Arthur Taussig (1941–)
Taos, New Mexico 1976
dye transfer photograph
12⅞" × 8½"
Courtesy of the Robert Freidus Gallery, Inc.,
New York

PLATE 40
Robert M. Ellis (1922–)
Studio Bay with View of Valdez Valley #1 1976
drawing, pencil with four color process
29" × 22"
Collection of the Museum of Fine Arts,
Museum of New Mexico, Santa Fe
Gift of the artist

PLATE 41
Miguel M. Padilla (1954–)
Ranchos Differente 1976
acrylic
24" × 30"
Collection of J. Raul Gonzalez, Santa Fe

PLATE 42
Douglas Kent Hall (1938–)
Ranchos de Taos Church 1976
gelatin silver photograph
13⅛" × 18⅞"
Collection of the artist

PLATE 43
Robert Brewer (1950–)
Lighting the Luminarias 1975
black and white photograph
8" × 10"
Collection of the artist

PLATE 44
Emil Bisttram (1895–1976)
Ranchos de Taos Church—Night 1974
oil
27½" × 36"
Collection of Mr. and Mrs. Grant Wilkins,
Colorado

PLATE 45
Julia Oros Williamson (1918–) P.S.A.
*Christmas Eve—St. Francis of Assisi Mission, Ran-
chos de Taos, New Mexico* 1977
pastel
21¼" × 16"
Private Collection

PLATE 46
Bernard Plossu (1945–)
Ranchos de Taos, Winter 1977/78
Fresson print
16½" × 24¼"
Collection of the Museum of Fine Arts,
Museum of New Mexico, Santa Fe
Anonymous gift

PLATE 47
Robert Daughters (1929–)
Winter Reflections In Ranchos 1977
oil
30" × 24"
Collection of Mr. and Mrs. Clarence Parsons,
Shawnee Mission, Kansas

PLATE 48
Douglas Johnson (1946–)
Church at Ranchos de Taos 1977
casein
8¾" × 8½"
Collection of Mr. and Mrs. Gerald P. Peters
III, Santa Fe

PLATE 49
Siegfried Hahn (1914–)
*Clearing of Autumnal Afternoon Shower, Ranchos
de Taos, New Mexico* 1978
oil
32" × 46"
Collection of the artist

PLATE 50
James Kramer (1927–)
Ranchos de Taos Church 1979
watercolor
14" × 21"
Private Collection

PLATE 51
Lou Stoumen (1917–)
Ranchos de Taos Church, New Mexico 1978
gelatin silver photograph
8⅞" × 8⅞"
Collection of the artist

PLATE 52
Steve Yates (1949–)
Painted Church: Erased de Taos 1978/1981
Ektacolor photograph with acrylic
20" × 25"
Collection of the artist

PLATE 53
Grey Crawford (1951–)
Untitled 1979
Ektacolor photograph
14⅝" × 18¹³⁄₁₆"
Collection of the artist

PLATE 54
Ruffin Cooper (1942–)
Taos Church III 1979
Ektacolor photograph
48" × 48"
Courtesy of the Elaine Horwitch Gallery,
Santa Fe

PLATE 55
James O. Milmoe (1927–)
Ranchos de Taos Mission 1965, print 1982
Ektacolor photograph
15⅞" × 16⅞"
Collection of the artist

PLATE 56
Edward Ranney (1942–)
Ranchos de Taos, N.M. 1979
gelatin silver photograph
6¾" × 9⁷⁄₁₆"
Collection of the artist

PLATE 57
Bill Gersh (1943–)
Ranchos Steeple Dog 1983
oil and oil pastel
11½" × 15¼"
Collection of Monty Ranes, Santa Fe

PLATE 58
Fritz Scholder (1937–)
Ranchos Church 1979
oil
30″ × 40″
Collection of Howard and Mara Taylor, Taos

PLATE 59
Barbara P. Van Cleve (1935–)
Big Dipper over St. Francis of Assisi Church at Ranchos de Taos 1981
Ektacolor print from Ektachrome transparency
6¼″ × 9½″
Collection of the Museum of Fine Arts, Museum of New Mexico, Santa Fe
Gift of Deede Phillips

PLATE 60
John Nieto (1936–)
Ranchos de Taos Church 1980
silkscreen print
28″ × 22″
Collection of the artist

PLATE 61
Kay Harvey (1939–)
Ranchos de Taos Church 1981
oil
23″ × 29″
Collection of Paul Peralta-Ramos, Taos

PLATE 62
Robert B. Miller (1948–)
Ranchos de Taos Church 1979
gelatin silver photograph
16″ × 20″
Collection of the artist

PLATE 63
Jean Dieuzaide (1921–)
Ranchos de Taos 1981
gelatin silver photograph
13½″ × 9⅝″
Collection of the artist

PLATE 64
Larry S. Ferguson (1954–)
#31–35–4 Church Dog, Ranchos de Taos, New Mexico 1981
gelatin silver photograph-selenium toned
8½″ × 12″
Collection of the artist

PLATE 65
Wolfgang H. Pogzeba (1936–1982)
Untitled 1981
black and white photograph
13⅜″ × 10¼″
Estate of Wolfgang H. Pogzeba

PLATE 66
William Acheff (1947–)
Northern New Mexico, 1900 1981
oil
28″ × 24″
Collection of Mr. and Mrs. Max D. Shriver, Santa Fe

PLATE 67
Vladan Stiha (1908–)
Ranchos de Taos Church, St. Francis de Asís 1981
oil
23″ × 29″
Collection of the Museum of Fine Arts, Museum of New Mexico, Santa Fe
Gift of the artist

PLATE 68
Gary Niblett (1943–)
Heavy Laden 1982
oil
15¼″ × 23½″
Private Collection

PLATE 69
Bill Buckley (1946–)
San Francisco de Asís 1982
black and white photograph
16″ × 20″
Collection of the artist

PLATE 70
Frederico Vigil (1946–)
Encuentro en Ranchos 1982
acrylic
36″ × 42″
Collection of the Museum of Fine Arts, Museum of New Mexico, Santa Fe
Anonymous gift

PLATE 71
Michael Stack (1947–)
Days Passing 1982
oil
18″ × 24″
Courtesy of Dewey Galleries, Ltd., Santa Fe

PLATE 72
Paul Strisik (1918–)
Ranchos de Taos 1982
oil
20″ × 40″
Private Collection

PLATE 73
Ron Robles (1937–)
Ranchos de Taos Church 1979
acrylic
40″ × 72″
Collection of Meg Heydt, Santa Fe

PLATE 74
William Cooper (1939–)
Taos Memory 1982
acrylic
42″ × 54″
Private Collection

PLATE 75
Charles Van Maanen (1921–1984)
Cross and Tower 1982
Kodachrome
(Slide from the photographic essay, *San Francisco de Asis Church*)
Collection of Olga Van Maanen, Encinitas, California

PLATE 76
Susan Zwinger (1947–)
San Raphael Visits St. Francis 1982
pencil drawing
22¼″ × 30″
Collection of E. David Burk, M.D., Galisteo, N.M.

PLATE 77
Jim Shea (1954–)
Untitled 1981
gelatin silver photograph
6¾″ × 9⅞″
Collection of the artist

PLATE 78
Eric Sloane (1905–1985)
The Mission at Ranchos 1982
oil
15½″ × 25½″
Collection of Mr. and Mrs. Robert Abel, Coto de Caza, California

PLATE 79
Douglas Keats (1948–)
Ranchos de Taos, I, II, III, IV 1984
Fresson prints
9½″ × 14″
Collection of The Albuquerque Museum, Albuquerque

PLATE 80
Paul Logsdon (1931–)
Ranchos de Taos, St. Francis 1986
cibachrome print
8″ × 10″
Collection of the artist

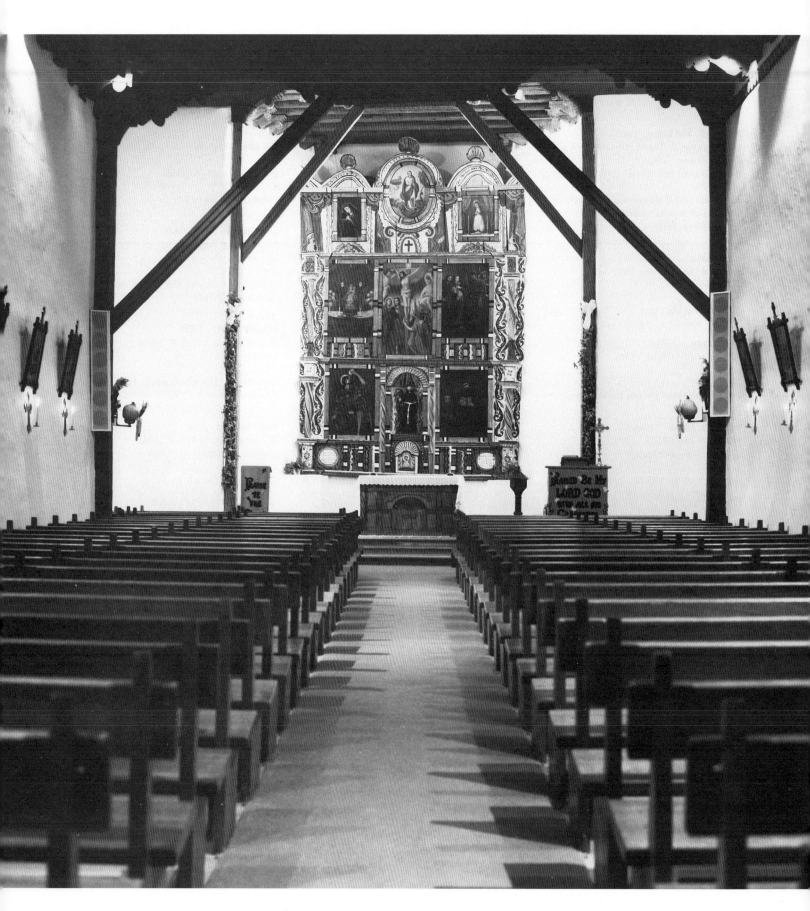

FOREWORD

I am honored to write the foreword for this book on the magnetic attraction of artists in this century to the parish church at Ranchos de Taos. The effects of the adobe shapes at Ranchos have been recorded in many versions by people of talent, as if, in doing so, they could capture something essential about the nature of New Mexico. No other church in the state has been recorded as often, and no convincing explanation of its appeal is known to me. Yet I have thought about such architecture in New Mexico off and on for fifty years, and would like to make two points; the first concerns the state of architectural taste in the 1930s, and the second, the cultural symbolism of the Ranchos Church.

Yale College in the 1930s was a hotbed of architectural debate. During the years of the Great Depression, the academic Gothic quadrangles for the entire university were built on designs from the office of James Gamble Rogers. This was an effective way to make new jobs using local labor for intricate tracery and sculptured woodwork with the munificent Harkness gifts. To undergraduates reading about the International Style in Europe, however, the immediate future seemed clear: bare, simple shapes stripped down to functional nudity were the way, and for me, the way led to New Mexico. Since then, of course, I have come to love academic Gothic as well. But the taste for the International Style was based on a particular set of moral and ideological values, which, being absent in New Mexico, made its appeal even more powerful to me as a field for study.

During the colonial era all of New Spain, from California and New Mexico to Guatemala, was a world of three emerging peoples—Amerindians, colonists, and mestizos. Their existence was always obvious, but no government recognized this demographic trinity until the creation of the Plaza de las Tres Culturas at Tlatelolco in Mexico City in the 1960s.

Ringed by high-rise office buildings, the marketplace and temple precinct excavations open into the foundations of the pyramid under the foot of the Franciscan Church in whose cloisters the Colegio de Santa Cruz served in the sixteenth century as a university for the sons of Indian ruling families. The plaza is an open-air archaeological museum and a national monument to the three cultures, as well as a martyrium where many university students died in a riot quelled by police.

A similar demographic trinity can be found today in the Rio Grande basin of New Mexico. The Indian pueblos are in the river valley, the Hispanic settlers have spread to the mountains and back to the towns, and the Anglos have tied New Mexico to the rest of the world. The magnetic attraction of the Ranchos Church is comparable to that of the Plaza de las Tres Culturas, rooted in an Amerindian past, functioning in a Hispanic village, and drawing to its study those from throughout the world who value its expression of balance among different peoples coexisting in a tolerant tension. New Mexico may be a paradigm of the whole United States, and the church at Ranchos de Taos may express its complex balance.

Vincente M. Martinez
Main Reredo (*Altar*), *St. Francis of Assisi Church*
1981

George Kubler,
New Haven, Connecticut

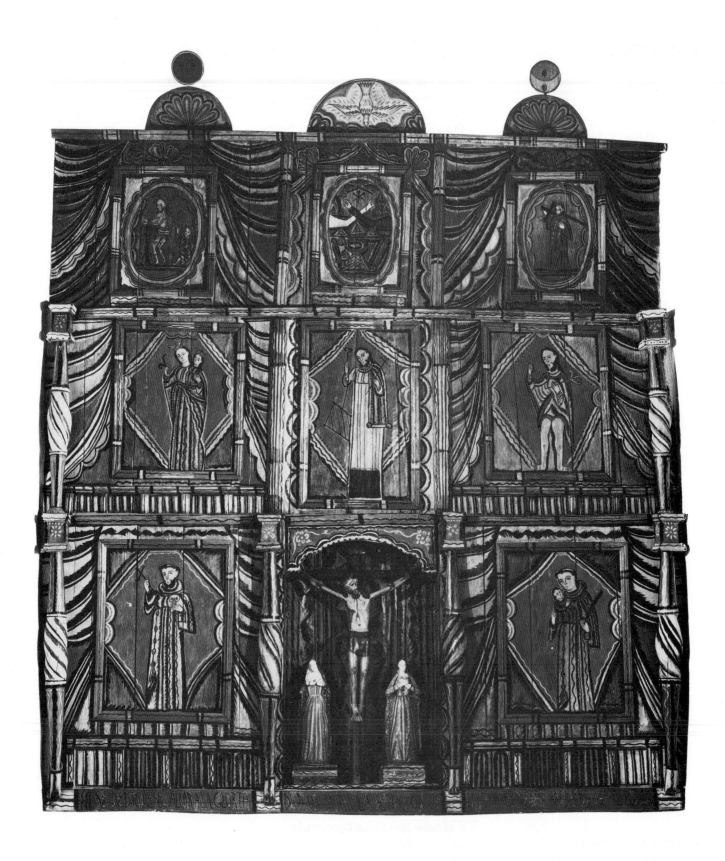

PREFACE

The mission church of San Francisco de Asís, located in Ranchos de Taos, New Mexico, is considered one of the finest examples of Spanish Franciscan architecture in the United States. This hand-plastered church is also one of the most painted and photographed buildings in the world. *Spirit and Vision: Images of Ranchos de Taos Church* is a tribute to the church, both as a religious structure and as a subject for art.

Since the beginning of the twentieth century, hundreds of painters and photographers have come to Ranchos de Taos to depict this arresting study of form, line, space, light, and shadow. Casting its spell on artists and visitors alike for almost a hundred years, the Ranchos Church has become a landmark of the Southwest and an important icon for artists of all persuasions. All the while it has endured as a cultural and religious center for Hispanic Catholics living in the area. This mission church, built of adobe, the Pueblo Indians' building material, later to be painted and photographed primarily by Anglo artists, can be said to represent a blend of the three cultures of Northern New Mexico. In this sense, the Ranchos Church and its artistic images have come to symbolize the area.

This book grew naturally out of the exhibition *Images of Ranchos Church* curated by Susan Streeper and myself and held at the Museum of Fine Arts, Museum of New Mexico, Santa Fe, from December 17, 1982, to April 24, 1983. Susan volunteered hundreds of hours of her time in helping me with the exhibition. She organized and managed the numerous details involved and was a continuing support throughout the exhibition's development. It was she and Janet Webb of Webb Design Studio, Taos, the designer of this book, who initially encouraged the publica-

tion. The exhibition was supplemented by a traveling photographic exhibition, *Ranchos de Taos: An Exploration in Photographic Style*, curated by Norman Geske, former director, Sheldon Memorial Art Galleries, University of Nebraska Art Galleries, Lincoln. Selections from these two exhibitions plus other works which were not included in the exhibition are found in this book.

I am honored by and thankful to the people who contributed to the text of this publication. Dr. George Kubler of the Department of Art, Yale University, New Haven, and author of the well known book *The Religious Architecture in New Mexico in the Colonial Period and Since the American Occupation* wrote the foreword emphasizing the architectural taste during 1930s and the cultural symbolism of the Ranchos Church. Dr. John L. Kessell, Associate Professor of History at the University of New Mexico and the author of many works, including *The Missions of New Mexico Since 1776*, contributed an essay on the church's beginnings.

Dr. Kessell's essay is joined by an essay by Suzan Campbell, former Curator of Contemporary Art at the Museum of Fine Arts, Museum of New Mexico, and myself. Chronologically organized, this essay offers a stylistic analysis of the church's images and their cultural and aesthetic significance. It recognizes the important role these artists' images have played in the rich artistic heritage of New Mexico and places them within the context of twentieth-century American art.

A book of this scope enlists the support, help, cooperation, and expertise of many people. I wish to thank the following: Luther Wilson, Jr., former director of the University of New Mexico Press, Albuquerque, and now director of Syracuse University Press, Syracuse, for his continuous encour-

ente M. Martinez
ar de Los Hermanos (*Molleno*)
1

agement and belief in this project; Dr. Peter Walch, Director, University Art Museum, University of New Mexico, for his guidance; Art Taylor, Museum of New Mexico photographer, for his superb transparencies of most of the works; the Administration of the Museum of New Mexico for their support; my colleagues at the Museum of Fine Arts, Museum of New Mexico, especially David Turner, Associate Director, for his direction and suggestions; Theresa Arellano, for her hours of typing; the late Sue Critchfield, librarian, for her help with research and documentation; Phyllis Cohen, the museum's current librarian, for her research; Cynthia Sanchez, former Assistant Curator of Contemporary Art, and Lorraine Cook; the Museum of New Mexico Foundation, especially Sandra Edelman, Executive Director, and Sucha Cardoza, office manager, for their assistance; the Museum of New Mexico Press staff, notably Sarah Nestor, former editor, and Mary Wachs, current editor, for their expertise and suggestions, and Jim Mafchir, Director; Sister Emilia Atencio and Corina Santistevan, San Francisco de Asís Church, for their support and guidance; Dr. Sharyn Udall, whose book, *Modernist Painting in New Mexico, 1913–1933*, was invaluable; Mrs. David Gottlieb for her interest and support; and Edna Robertson, former curator, Museum of Fine Arts, Museum of New Mexico, who was my mentor.

For their extensive research and documentation of biographical information on the artists, although not used in this publication, I wish to thank Sheila Maney, Museum Intern, Museum of Fine Arts, Museum of New Mexico; Anthony Montoya, former Curator of Photography at the Sheldon Memorial Art Galleries and current director of the Paul Strand Archive in Millerton, New York; Liga Tigeris, Museum Intern, Sheldon Memorial Art Galleries; and Cathy Liggon, of Santa Fe, for her typing assistance and expertise.

My gratitude goes especially to the artists, who have been helpful, enthusiastic, and extremely willing to loan their works and supply biographical information and documentation throughout the project; and to the museums, galleries, and private collectors for their assistance and generous permission to reproduce the works in this publication, notably Elizabeth Cunningham, Curator, The Anschutz Collection, Denver; Peter Briggs, former Curator of Collections and Neil Morgenstern, former Assistant to the Curator of Collections, and Kevin Donovan, Curator of Collections, University Art Museum, University of New Mexico, Albuquerque; Janet Dorman, Coordinator of Photographic Services, The Phillips Collection, Washington, D.C.; Marni Sandweiss, Curator of Photography, Amon Carter Museum of Western Art, Fort Worth; David Witt, Curator of Collections, Harwood Foundation of the University of New Mexico, Taos; Mary Street Alinder, Executive and Business Manager, Ansel Adams Publishing Rights Trust, Carmel, California; Anthony Montoya, Director of the Paul Strand Archive, Millerton, New York; Christine Knop Kallenberger, Registrar, Philbrook Art Center, Tulsa; Henry A. Sauerwein, Director, Helen Wurlitzer Foundation, Taos; Laura B. Hoge, Registrar, Colorado Springs Fine Arts Center, Colorado Springs; Ray Dewey, Dewey Galleries, Ltd., Santa Fe; Elaine Horwitch, Elaine Horwitch Gallery, Santa Fe; Forrest Fenn, Fenn Galleries, Ltd., Santa Fe; John Manchester, Designer, Roger P. Thomas, Executive Designer, Fine Arts Collection, Valley Bank of Nevada, Las Vegas; Linda M. Lebsack, Rosenstock Arts, Denver; Rena Rosequist and the late Ivan Rosequist, Mission Gallery, Taos; Tally Richards, Tally Rich-

ards Gallery, Taos; Robert Freidus, Freidus Gallery Inc., New York; Mr. and Mrs. Charles M. Batts, Santa Fe; Hazel and Kenneth Warren, Berkeley; Mr. and Mrs. Bennet L. Price, Aurora, Colorado; Mr. and Mrs. Max D. Shriver, Santa Fe; Mrs. Joseph McKibbin, Santa Fe; Mrs. Robert Lougheed, Santa Fe; Mr. and Mrs. Clarence Parsons, Shawnee Mission, Kansas; Mrs. Burnham L. Batson, Savannah; Mr. and Mrs. Edward D. Gladden, Albuquerque; Mr. James Alinder, Mill Valley, California; Meg Heydt, Santa Fe; Mr. and Mrs. Grant Wilkins, Colorado; Mr. J. Raul Gonzalez, Santa Fe; Mr. and Mrs. Gerald P. Peters, III, Santa Fe; Howard and Mara Taylor, Taos; Mr. Paul Peralta-Ramos, Santa Fe; Catherine M. Harvey, Santa Fe; Mr. Monty Ranes, Santa Fe; E. David Burk, M.D., Santa Fe; Bishop Everett Jones and the late Helen Miller Jones, San Antonio; Dr. Richard and Susan Streeper, Santa Fe; and Mr. and Mrs. Robert Abel, Coto de Caza, California.

I wish to thank my friends who inspired and encouraged me: James R. Marmon, Caroline Adams, Eleanor Castro, Ruth Greig, Cathy Liggon, Nargis, Roger Armstrong, Bruce Stroud, Susan Streeper, Barbara Biber Janeff, Jeralyn Myers Pinsky, and Kay Harvey; to my family: Dolores Danzig; Duncan and Sally Scott;

Jim and Patricia Steindler; Dr. Elliott and Bertha Danzig; John D'Emilio and Danica D'Emilio; Jim, Susan, and David Hogan; David and Sue Wilson, Christopher Olson, Harvel Turner, Vernon and Brandy Turner, Suzanne Street, Lynn and Louise Kelly, Jean Nicholson, Harold and Barbara Kramer Garde, and Loulynn Townsend; Joyce and the late Rudolph Ray, Margo and Arnold Deutsch, and the late John Star Cooke.

For their financial support and generosity, I wish to thank the following people: Helen Greene Blumenschein, Taos; Bambi Ellis, Santa Fe; Alexandre Hogue, Tulsa; Douglas Johnson, Coyote, New Mexico; Gene and Phillips Kloss, Taos; Mr. and Mrs. Morris Rippel, Albuquerque; the late Fred A. Rosenstock, Denver; Myrtle Stedman, Tesuque; Vladan and Elena Stiha, Santa Fe; Dr. Richard and Susan Streeper, Santa Fe; Barbara P. Van Cleve, Santa Fe; The Museum of New Mexico Foundation; and the many anonymous donors.

To all of the above and to those that I may have inadvertently overlooked, I thank you.

Sandra D'Emilio
Curator of Painting
Museum of Fine Arts
Museum of New Mexico

"The accident that started the Taos Art Colony," by Bert G. Phillips, 1898.

MISSION OF BEAUTY: THE ART OF RANCHOS DE TAOS CHURCH

Sandra D'Emilio and Suzan Campbell

The Ranchos de Taos Church has been portrayed more often, by more artists, than any other church in the United States, perhaps in the world. It has been interpreted so widely that it has become an artistic icon.

Artists have been drawn to the church as subject matter for nearly one hundred years. They have arrived from all directions, but most have approached it from the south. The road through the Sangre de Cristo Mountains north of Santa Fe grows steadily more dramatic as it approaches Taos. After skirting several miles of broad valleys where small farms and apple orchards spread like patchwork from the banks of the Rio Grande, the road enters a narrow canyon. Here, steep, rugged mountains spill rocks down to one edge of the highway, while the Rio Grande winds sinuously along the other. Then suddenly the road climbs out of the canyon, rounds a long curve, and opens onto a large mesa divided by a great, deep crack in the earth—the magnificent Rio Grande Gorge. The Taos Mountains, almost perpetually capped in snow, provide the backdrop for this breathtaking panorama.

From this point the road slowly descends into the Ranchos de Taos valley and through the small village of Ranchos de Taos, the site of the Church of San Francisco de Asís, known more commonly as the Ranchos de Taos Church, or, simply, the Ranchos Church. The road passes not in front of, but behind, the Ranchos Church. From this vantage point one might fail to recognize the mysterious sculptural form as a church at all. Yet its commanding presence dominates this rural landscape.

The church's size and its building materials and design belie its power. A small structure made of earth and wood, it is largely unadorned. But it seems almost perfectly proportioned and is imbued with natural grace. In harmony with its surroundings, the Ranchos Church exerts a quiet force which has universal appeal.

The mission churches of New Mexico, designed by

Spanish Franciscans in the seventeenth and eighteenth centuries and built of indigenous materials with Indian labor, are symbols of Hispanic Catholicism in the Southwest. Though constructed comparatively recently—1815 is the probable date of completion—the Ranchos Church is perhaps the finest example of the blend of the Franciscans' Old World architectural ideals and New World building techniques.

Massive adobe buttresses seem to anchor the church to the earth in a timeless union. Throughout the day light plays on these rounded, asymmetrical forms, casting irregular shadows on the thick adobe walls and the ground. The elegant structure is a constantly changing study of line, light, time, and space.

As the Ranchos Church absorbs and reflects the light it also absorbs and reflects human feeling, particularly that of the local parishioners, who have infused this building with their spirit as they have built, plastered, and replastered its sculptural surfaces over the years.

Many artists who were lured to New Mexico by its exotic landscape and culture arrived already influenced by modernist art and ideas. The surrealist and expressionist images they encountered—common features of the New Mexico landscape—were well suited to their exploration of trends in twentieth-century art. Newcomers quickly became accustomed to orange skies and violet earth; to clouds that appear as mountains, and mountains that seem as ephemeral as clouds; and to being where miracles are a part of everyday life, and where everyday life seems somehow miraculous.

During the early years of this century, artists' interest in modernist trends—reinforced by their discovery of "primitive"[1] art—and their desire to find indigenous American subjects worthy of their artistic goals led many of them to the impressive sculptural form of the Ranchos Church. Yet the church's appeal has never been limited to those artists who express modernist ideas in their work.

For many, the more traditional aspects of the church, as a center of religious life in the community and as a living symbol of Hispanic culture, are a large part of its attraction as subject matter. Other artists wish simply to document the church as faithfully as they can.

Artists working in New Mexico from the 1840s on documented the flora, fauna, and topography of the state for geological survey and census expeditions. But it wasn't until the turn of the century that artists traveled to New Mexico seeking inspiration and subjects for their work.

Joseph Henry Sharp (1859–1953), who visited Taos for

1. William Rubin, ed., "*Primitivism*" *in 20th Century Art—Affinity of the Tribal and the Modern*. (New York: Museum of Modern Art, 1984). In his introduction, Rubin discusses the term "primitivism," saying, "it refers not to the tribal arts in themselves, but to the Western interest in and reaction to them. Primitivism is thus an aspect of the history of modern art, not of tribal art.... The 'effective connotations' of 'primitive' when 'coupled with the word art,' as Robert Goldwater concluded [in his book, *Primitivism in Modern Painting*, 1938] are 'a term of praise.'"

the first time in 1893, is recognized as the spiritual father of the Taos art colony.[2] Ten years earlier, Sharp had realized his lifelong ambition to travel to the American West to paint the Indians. During that visit to Santa Fe, he ventured to nearby pueblos to paint Indian ceremonial dances, but he did not visit Taos. It was during his second trip to New Mexico that he journeyed to that northern town, this time as a professional artist on assignment to illustrate the Taos pueblo for *Harper's Weekly*.

Sharp's enthusiasm for the dramatic landscape of northern New Mexico, the Pueblo Indians, and village Hispanics as unheralded subjects for art was contagious, and he infected two fellow American students he met in 1895 while they were studying together at the Academie Julian in Paris. Ernest Blumenschein (1874–1960) and Bert Geer Phillips (1868–1953) were so inspired by Sharp's sketches of the landscape and stories of colorful Indian culture that they decided to make an extensive sketching trip through the West. By 1898 they had saved enough money for a summer tour through southern Colorado and New Mexico, and a winter in Mexico.

The pair departed Denver in a horse-drawn wagon loaded with camping and art supplies and spent the summer traveling and sketching through southern Colorado. By September they were in New Mexico, where they encountered nearly impassable roads. Twenty miles north of Taos, a wagon wheel broke, and Blumenschein lost a coin toss to see which of them would carry the wheel on horseback into Taos for repair.

> At four P.M. on the third of September, 1898, I started down the mountain, on what resulted in the most impressive journey of my life.... What had seemed a simple job when we tossed the coin, had become a painful task. The wheel grew larger and heavier as I shifted it to all conceivable positions.... Vividly I recall the discomfort ... until I reached Taos, a dim picture of which I had made from Sharp's slight description. But Sharp had not painted for me the mountains or plains or clouds. No artist had ever recorded the superb New Mexico I was now seeing. No writer had, to my knowledge, ever written down the smell of this sage-brush air, or the feel of the morning sky. I was receiving, under rather painful circumstances, the first great unforgettable inspiration of my life. My destiny was being decided ... New Mexico had gripped me—and I was not long in deciding that if Phillips would agree with me, if he felt as inspired to work as I, the Taos valley and its surrounding magnificent country would be the end of our wagon trip.[3]

Though Blumenschein returned to the East after a few months, Phillips remained in Taos, the first artist to settle there. Blumenschein often returned to Taos to paint, and by

2. Patricia Janis Broder, *Taos: A Painter's Dream*, (Boston: New York Graphic Society, 1980), p. 5.
3. Ernest Blumenschein, "The Broken Wagon Wheel: Symbol of Taos Art Colony," *Santa Fe New Mexican*, 1939.

1910 he was spending summers in Taos painting what he liked, supported by his work as a commercial artist in New York City. He and his family permanently settled in Taos in 1919.

E. Irving Couse (1866–1936), a successful academic figure painter whose work idealized Indians, had also been influenced by Sharp, whom he met in Paris in 1896 and again in 1900. He arrived in Taos in 1902 to discover his ideal subject, the Pueblo Indians. He returned each summer until 1927, when he, too, became a permanent resident.

With Oscar E. Berninghaus (1874–1952), who arrived in 1899, the informal group of artists in Taos grew to five. Berninghaus received a commission from the Denver and Rio Grande Railroad to make watercolor sketches of the Southwest for travel pamphlets. While a passenger on the "Chili Line," the narrow gauge railroad which cut south through northern New Mexico, ". . . the brakeman pointed out a certain mountain lying toward the east; this he called Taos Mountain and told me of a little Mexican village of the same name and the Indian Pueblo lying at the foot of it . . . describing it all so vividly that I started on a twenty-five mile wagon trek. . . . After a hard journey I arrived in Taos late in the afternoon, the sun casting its glowing color over the hills that gave the Sangre de Cristo mountains their name."[4] He, too, returned each summer to paint, and in 1925 to remain permanently.

In 1911, W. Herbert Dunton, a commercial illustrator living in New York City, became a student of Ernest Blumenschein's at the Art Students League. The following year, Blumenschein persuaded Dunton to visit Taos.

That same year, Joseph Henry Sharp returned to settle in Taos. It was in the summer of 1912 that these six artists—Sharp, Blumenschein, Phillips, Berninghaus, Couse, and Dunton—began plans for the Taos Society of Artists. (The first meeting of the TSA was held on July 1, 1915; the organization existed until 1927.)

The TSA was formed primarily to provide exhibition and marketing opportunities for its member artists, there being no galleries and few tourists in the small village. In the constitution and bylaws of the new organization, the artists dedicated themselves to maintaining high standards in art and to encouraging "sculpture, architecture, applied arts, music, literature, ethnology and archaeology, solely as it pertains to New Mexico and the states adjoining."[5] They accomplished their goals by sponsoring traveling exhibitions, which proved both popular and commercially successful. As a result, TSA artists were able to remain in Taos, financially secure and free to paint what they wanted.

4. Laura M. Bickerstaff, *Pioneer Artists of Taos.* (Denver: Sage Books, 1955), p.8.
5. Broder, p. 9.

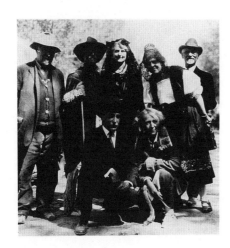

New Mexico's pioneers; standing, left to right: Irving Couse, Ernest L. Blumenschein, Mrs. Joseph Henry Sharp, Miss Grant, Joseph Henry Sharp; kneeling, left to right: Bert G. Phillips, Mary Ufer.

Many founding members of TSA had been trained in the most prestigious art schools in the United States and Europe and were steeped in academic traditions. Their paintings were, for the most part, illustrative, decorative, and romantic. According to art historian Sharyn Udall, "... these TSA paintings differed little in spirit from their eastern contemporaries in that era of realistic, colorful painting enlivened with varied brushwork and often burdened with excessive sentimentality. The approach was essentially the same; it was the subject matter that differed."[6]

Several TSA artists were romantics who idealized the West and the past; others had anthropologic and ethnologic interests. For each of them, the mountains, canyons, arroyos, and plains, and the Hispanic people and Pueblo Indians, provided the unique, exotic subjects they sought. That these subjects were indigenous to America, rather than to Europe, was no less important to these American artists.

Unlike earlier, documentary artists, TSA artists depicted the Indian in a new way. "The Indian as a motif, for example, became a decorative rather than a historic model. Scenes of Indian life were removed from action, transformed into studies of mood and character. Nostalgia replaced history; pattern and medley were gradually substituted for human drama."[7]

The Taos artists also painted the local adobe architecture, including the mission churches, of which the Ranchos Church was one of the most frequently depicted. Ernest Blumenschein's painting *Church at Ranchos de Taos*, before 1917 (Plate 2), exemplifies the romantic tradition which was associated with the TSA. In this dynamic scene, the static mass of Ranchos Church is the highlighted backdrop for the actors in the foreground, several Taos Pueblo Indians clad in white cotton trade blankets. His billowing blanket and bright turquoise sash focus attention on one horseman, who is flanked by two Arab-looking figures. The drama and romance in this work are amplified by the intense evening light on the south side of the church and the cloud-filled sky with its wind-swept birds. The contrast of intense light with dark shadows, coupled with the Indians' enveloping white blankets, add to the mood of mystery and intrigue. While Blumenschein admired impressionist and post-impressionist painting and believed in the importance of experimentation in art, this highly romanticized portrayal reveals the conservative influence of Blumenschein's teacher at the Academie Julian, Benjamin Constant, who was well known for his genre paintings of Morocco.

Oscar Berninghaus was a self-taught artist who painted in an objective, straightforward style. As a young man he

6. Sharyn Rohlfsen Udall, *Modernist Painting in New Mexico 1913–1935*. (Albuquerque: University of New Mexico Press, 1984), p. 12.
7. Peter Hassrick, *The Way West: Art of Frontier America* (New York: Harry W. Abrams, Inc., 1972), p. 23.

learned the basic principles of design and precision draftsmanship while an apprentice to a printing company. He later became a commercial artist and received the commission that took him to New Mexico in 1899 and changed his life. Before his arrival in New Mexico, he had never painted in oil; as a result of his visit he was filled with a sense of purpose and vowed to dedicate his life to painting.[8] In a letter he wrote in 1950, he said, "Fascinated by the people, the Indians and Mexicans, the adobe architecture, the sagebrush, the mountains, they all inspired me as subject matter."[9]

His concern for realistic detail is evident in his treatment of the dress of the church congregation, the carved wooden doors, and the wooden bell towers in his painting *Church at Ranchos de Taos*, ca. 1920 (Plate 6). This genre scene lacks the exotic excitement of Blumenschein's *Ranchos*, but it has an air of repose created by the calm, cloudless sky, the peacefully assembled crowd, and the complementary, naturalistic colors in the painting. Building and cross occupy the center of this harmonious composition, and the cross leans slightly toward the congregation, as if in benediction.

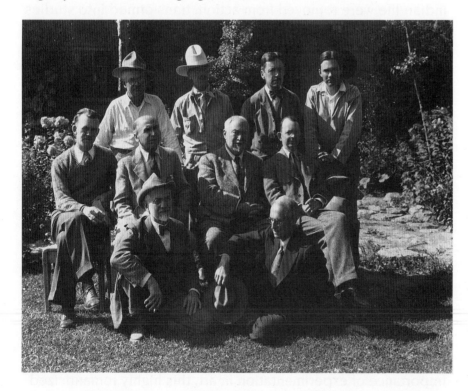

The "Taos Ten," 1932; *standing, left to right*: Walter Ufer, W. Herbert (Buck) Dunton, Victor Higgins, Kenneth Adams; *seated, left to right*: E. Martin Hennings, Bert G. Phillips, E. Irving Couse, Oscar E. Berninghaus; *front row, left to right*: Joseph Henry Sharp, Ernest L. Blumenschein.

Although by 1912 Taos was an established art colony, Santa Fe, seventy miles to the south, had not yet become an art center. Many of those artists who did settle in Santa Fe after the turn of the century suffered ill health and came seeking the dry, sunny climate.[10] As war on the continent became a real

8. Broder, p. 119.
9. Bickerstaff, p. 9.
10. Edna Robertson and Sarah Nestor, *Artists of the Canyons and Caminos* (Layton, Utah: Peregrine Smith, 1976), p. 15.

threat, many artists who had planned to travel in Europe were forced to alter their plans and went instead to the Southwest, some to Santa Fe. The presence in northern New Mexico of "primitive" indigenous subjects fed many artists' concerns. By 1917, the year the United States entered the war, and the year the Museum of New Mexico's new Fine Arts Museum was completed in Santa Fe, an impressive roster of artists had either visited or settled in the town.

The dream of a museum for New Mexico had been shared by Dr. Edgar L. Hewett, an archaeologist, and Frank Springer, New Mexico territorial senator, scientist, and patron of the arts, from the time they met in 1898. By 1909 the Museum of New Mexico was established, housed in the historic Palace of the Governors on the plaza. A group of artists, architects, and archaeologists gathered around Hewett, who served as first director of the museum. These men developed a keen interest in the indigenous architecture of New Mexico, exemplified by the adobe mission churches, and promoted it as the only truly American architecture. Artist Carlos Vierra, a contemporary of the time, described it as "a free-hand architecture with the living quality of a sculptor's work, and that pliant, unaffected and unconfined beauty characteristic of natural growth . . . bearing the closest relation to the surrounding landscape. . . ."[11] Jesse Nusbaum (1887–1975), the archaeologist-ethnologist who supervised construction of the museum in 1916–17, traveled through the state photographing mission churches, which served as models for a synthesized architectural style Hewett's group termed "Spanish Pueblo Revival," or "New-Old Santa Fe Style." The fine arts building was the prototype of this style.

One of the earliest photographs of the Ranchos Church is probably that made by Nusbaum around 1912 (Plate 1). This photograph, probably made during a re-roofing project (vigas are propped against the south side of the building), was most certainly made to document the building for the architectural project. Nevertheless, aesthetic considerations are evident in it—for instance, the church is set off from the center of the image so that surrounding buildings and a black-cloaked woman can be included.

The Museum of Fine Arts in Santa Fe was a larger replica of the official New Mexico building, called the "Cathedral in the Desert," at the 1915 Panama-California Exposition in San Diego. Among the most popular there, it received "the admiration of throngs daily,"[12] and enthusiastic Santa Feans raised funds to have it preserved in the form of a fine arts museum. To achieve the organic spontaneity of neo-Pueblo

11. Carlos Vierra, "New Mexico Architecture," Art and Archaeology VII (January/ February, 1918):42.
12. El Palacio, January, 1915, Vol. II, p. 1.

architecture, conventional building techniques had to be unlearned and new ones learned by the craftsmen working on the museum. Of the undulating walls of the building Jesse Nusbaum boasted, "Not a line in plumb!"

The museum filled a great need of New Mexico artists. One of the first museums in the country devoted to contemporary art, it provided the only exhibition space in the area.

Artist Robert Henri, in a letter to a friend in 1917, said, "The new museum is a wonder . . . it is a treasure of art in itself, art of this time and this place, of these people and related to all the past. . . ."[13]

It was in San Diego, during the 1915 exposition, that Dr. Hewett had met Robert Henri (1865–1929), prominent New York painter and teacher and the leader of the "Ashcan School." Their association was to have far reaching consequences for the art colony in Santa Fe.

In 1908 Henri and other dissident artists, known as "The Eight," exhibited their work in New York City in a history-making break with the conservative art establishment represented by The National Academy of Design. The Academy sponsored annual juried exhibitions selected by their conservative members whose allegiance was to the academic impressionism then in favor. Henri believed that art should find its sources in everyday life, and that artists should be free from the dogmas of academia and the jury system. Though The Eight never exhibited together again, they continued to influence the art establishment. In 1910 these realists formed "The Independent Artists," dedicated to finding outlets for the exhibition and sale of *progressive* art in America. "Although the realist style practiced by the Henri group is far from what came to be known as 'modernist,' nonetheless, Henri and his students were aware of contemporary modernist aesthetic theory and insisted upon the artist's right to a free personal expression. In addition, Henri and John Sloan [a member of The Eight who from 1919 on spent his summers in Santa Fe], were instrumental in bringing progressive ideas on art to New Mexico."[14]

At Hewett's urging ("I am tremendously anxious to have the ideal in Art that you stand for brought into the ken of our people. . . .")[15], Henri visited Santa Fe in 1916, and again in 1917 and 1922. Once in Santa Fe, Henri advised Hewett to establish a liberal exhibition policy at the museum. As Hewett reported in the catalog of the museum's twentieth anniversary exhibition, "An 'open door' policy was adopted and has been consistently adhered to. Its alcoves have been open to the most eminent painter or sculptor, to the unknown beginner, . . .

13. Robert Henri to Henry Lovins, January 24, 1917.
14. Udall, p. xv.
15. Robertson and Nestor, p. 48.

all on equal terms. There has been no jury, no favoritism for any theory or 'school' of art. The Director's idea was to provide all the facilities possible within our means, then keep out of the way and give art a fair field."[16]

The open door policy laid the philosophical groundwork for the museum for many years to come. In 1951, shortly before his death, John Sloan adamantly (though unsuccessfully) protested the abandonment of the policy in his now-famous telegram to painter Will Shuster after the museum announced that for the first time its annual show would be juried.

> I have just heard that S.F. Art Museum is having its first Juried Ex.-STOP! . . . The famous Open Door Annual of Santa Fe will be no more. STOP. Robert Henri and Edgar Hewett will "turn in their graves" muttering - STOP. And now watch the miserable, puny, stinking, pallid efforts to show twentieth class imitations of the current fashions. OH STOP! . . . The 'Open Door' might have let in Publicity, Honesty, Equity. The jury will cause all these to - STOP.[17]

Gustave Baumann (1881–1971) was one of the early artists to settle in Santa Fe. When he was a small child, his family immigrated from Magdeburg, Germany, to Chicago. As a young man he attended the Chicago Art Institute at night, while working days in a commercial art studio.[18] While at the Institute, he met fellow students Walter Ufer, Victor Higgins, and E. Martin Hennings, all of whom later became members of the Taos Society of Artists. In 1905 Baumann went to Germany to study woodblock printmaking, then returned to Chicago to resume his work as a commercial artist. It wasn't until 1918 that he visited Santa Fe, but that visit heralded a permanent move for Baumann.

Baumann's impressionist style emerges clearly in his woodblock print *Church, Ranchos de Taos*, 1919 (Plate 3). The hundreds of small, chiseled marks parallel the fragmented brushstrokes of impressionist painters. These obvious, flickering marks create a rhythmic and textural excitement. Like the French impressionists, he avoided use of the color black. The golden path along which the parishioners walk on their way to early morning mass reflects the transitory early morning light. The blue shadows of the worshippers and those of the building are not their inherent color, but are a feature of the moment. Every area of the work reflects the glow of morning light. The feel of this new day is one of hope and renewal.

B.J.O. Nordfeldt (1878–1955) was also an immigrant, from Sweden, whose family also settled in Chicago, where he, too, studied at the Chicago Art Institute, in 1899. In 1900 Nordfeldt went to Paris to work on a mural for the Paris

16. Ibid., p. 150.
17. Ibid., p. 154.
18. Ibid. p. 117.

9

Exposition. His contact with modernist artists and ideas had a profound effect on the young artist, and he returned many times to Europe until 1915. In 1913, after stopping in New York to view the Armory Show, he and his wife departed for Paris, "for five years to work with those who, like myself, believe in progress."[19] Although the war cut his trip short, he did spend a year and a half there during a time of momentous change in French art and "immersed himself in the sea of change," according to Udall. She continues, "But the single most vigorous influence on his work was that of Cézanne, whose vision would color Nordfeldt's for years."[20]

During his Chicago years, Nordfeldt gained a significant reputation as a painter, printmaker—including woodblock printing and etching—and teacher. By the time he arrived in New Mexico in 1918, etching comprised most of his artistic output. His etchings were exhibited in the new museum soon after his arrival, and he made a series of etchings with Santa Fe themes on the museum's etching press. Nordfeldt was devoted to fine craftsmanship, and to portraying the Hispanic culture, which he eagerly studied. While the etching *Ranchos de Taos*, 1925 (Plate 5), does not show strong modernist influences, it still reveals Nordfeldt's interest in problems of reduction and "essential" form. The simplification of the church structure in this geometricly organized scene makes it the center of attention, although it is partially obscured by a large tree in the foreground. By the end of the 1920s Nordfeldt completely gave up etching in favor of painting.

Raymond Jonson (1891–1982) migrated east from Portland, Oregon, to Chicago and the Art Institute, where in 1911 he became a student of Nordfeldt's. To Jonson, Nordfeldt—sophisticated traveler and harbinger in Chicago of the latest innovations in European modernism—was a beacon of hope in his own quest to escape the stultifying limitations of provincialism. If Nordfeldt was a role model for Jonson in his Chicago period, he in turn took a special interest in the young artist's work. Throughout his career, Jonson credited Nordfeldt's artistic influence as the most important in his own work.[21]

During the teens and twenties Chicago hosted many modernist exhibitions and artists. Jonson and the group of local modernists he was involved with—labeled young radicals by conservative Chicago—carefully studied each modernist innovation and new theory to appear and exposed themselves to virtually every source and manifestation of European and American modernist thought.[22]

Jonson also traveled extensively in the West during this time, visiting, among many places, Santa Fe. In 1924 he

19. Udall, p. 73.
20. Ibid.
21. Udall, 92.
22. Udall, p. 94.

moved there, taking with him his interest in color, form, and rhythm. Andrew Dasburg (1887–1979), already in Santa Fe, shared Jonson's interest in the modernist aesthetic, especially cubism, which would preoccupy Jonson during his early years in Santa Fe.

Jonson and Dasburg's aesthetic compatibility was important to Jonson. He had renewed his friendship with Nordfeldt in Santa Fe, and they became neighbors and colleagues, but their ideas and work grew farther apart. In fact, Jonson's work differed stylistically from that of most New Mexico artists.

Jonson discovered that the geometric forms he sought were abundant in New Mexico, in nature as well as in architecture, and he emphasized their linear, angular, and planar qualities in his work. *Ranchos de Taos Church*, 1927 (Plate 7), is cubist in mood, if not strictly cubist in style. (The virtually frontal presentation of the church suggests overlapping planes, rather than simultaneous views). His interest in the planar qualities of the rear of the church is manifest through his use of contrasting light and dark areas to accentuate its geometric, angular aspects and to allow it to dominate the composition. The lithograph is a rhythmic combination of line, form, and contrast.

Raymond Jonson ca. 1935.

In 1927, the same year Jonson completed his *Ranchos*, he helped organize several Santa Fe artists, including Dasburg and Nordfeldt, into a group which, until 1931, held a series of exhibitions in the Fine Arts Museum, in an alcove gallery designated as the modern wing. The open door policy of the museum and the friendly encouragement of its staff provided

these artists crucial exhibition opportunities in a community which at best was indifferent, at worst, hostile, to the efforts of its modernist artists.

Despite the cool reception of conservative New Mexicans to their art and ideas, many modernist artists and writers found their way to New Mexico—among them John Marin, D.H. Lawrence, Marsden Hartley, and Georgia O'Keeffe—often as the guests of Mabel Dodge, who provided a vital link between the artists in isolated New Mexico and the mainstream of American and European modernist ideas. Dodge, a wealthy New Yorker, involved herself in radical ideas and causes. During the years 1913–1914, she hosted weekly "evenings," where liberal and radical ideas were discussed. Several artists who later found their way to New Mexico under her sponsorship attended these salons.

However, Dodge grew disenchanted with her bohemian life and eventually moved to Taos—strangely, as a result of her stormy marriage to painter Maurice Sterne (1878–1957). She had sent him to New Mexico in 1916 to paint ("I've heard there are wonderful things to paint. Indians. Maybe you can do something of the same kind as your Bali pictures...."),[23] recognizing that separation was balm to their tumultuous relationship. No sooner had he left, however, than Dodge began to see her own path as leading to New Mexico. Not only did Sterne send her enthusiastic letters about New Mexico, but a Brooklyn medium at about that time told her that her life would be devoted to helping Indians and, in turn, being guided by one of them. Dodge, who had long been involved in explorations of the mystic, succumbed to what she saw as her destiny, and arrived in Taos in 1917.[24] Once there, she divorced Sterne, married Tony Luhan, a Taos Indian, and with him built a house styled on the adobe architecture of the Taos pueblo.

Andrew Dasburg was living in Mabel Dodge's New York apartment in 1918 when she invited him to join her in Taos. He and Mabel had met in 1913 and became close friends, beginning what would be a lifelong relationship. By that time, Dasburg had a successful career in New York. He had been a student of Robert Henri there, and in Paris had spent time with Gertrude and Leo Stein and their avant-garde circle, and had seen the work of Matisse, Renoir, the Cubists, the Futurists, and that of Cézanne, whose vision made a profound impression on him.

In 1913 Dasburg was invited to exhibit in the New York Armory Show. The other artists' work he encountered in that exhibition so affected him that by 1916 his own work was almost entirely non-objective. He defended it, saying that the

Andrew Dasburg in 1932.

23. Mabel Dodge Luhan, *Movers and Shakers* (New York: Harcourt, Brace & Co., 1936), p. 532.
24. Udall, p. 12.

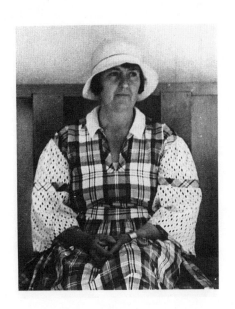

Mabel Dodge Luhan in Taos in 1932.

recognizable object detracted from the viewer's appreciation of formal qualities, and was therefore to be eliminated. He soon abandoned this extreme position, but the influence of Cézanne and the Cubists would never completely disappear from his work.[25] His *Spring in Ranchos*, 1974 (Plate 33), is classic Dasburg: the composition is based on independent lines which divide the plane diagonally rather than horizontally, and the subject has been simplified almost beyond recognition.

After his first visit to Dodge in Taos, Dasburg divided his time between New York and Santa Fe, which he preferred to the close confines of Mabel's world in Taos. In 1933 he became a permanent resident of Taos, and by the late 1930s, Dasburg was the best known modernist painter in New Mexico.

Among the many other artists and celebrities Dodge attracted to Taos were Leopold Stokowski, Thornton Wilder, Leo Stein, Mary Austin, and, of course, D. H. Lawrence and his wife Frieda, who brought British painter Dorothy Brett with them. Some stayed for short visits; others, like Lady Brett, remained in Taos for years.

Many of these relative latecomers to New Mexico found inspiration for their near-abstract painting in the stylized, boldly geometric art of the Indians and in the landscape. For many, though, New Mexico was simply an ideal place to wait out the war in Europe.

Paul Strand (1890–1976) and Ansel Adams (1902–1984) were both early visitors to the Dodge estate. In 1929, Strand's wife, Rebecca, and her close friend Georgia O'Keeffe (1887–1986) spent the summer with Dodge. The following summer Strand joined Rebecca on a return visit. Adams and Strand met while Adams was a guest in one of Dodge's houses and the Strands had rented another. As Calvin Tompkins describes, their friendship led to an important discovery by Adams:

> When Mrs. Luhan abruptly informed Adams that she needed his house for someone else, the Strands invited him to come and stay with them for a few days. The Strand house was about four miles from the adobe church of Ranchos de Taos, whose thick walls and buttresses were replastered by hand every year by the Indians [sic]. Strand used to watch the sky, and when he saw a storm coming he would get in the car, head for the church, and have his camera set up by the time the storm got there."[26]

Impressed by the quality of Strand's beautiful negatives and his ideas about photography, Adams gave up his dream of a career as a concert pianist and began to concentrate exclusively on photography, which up to this time had been only a secondary interest.

Adams and Strand were practitioners of photography

25. Udall, p. 57.
26. Calvin Tompkins, *Paul Strand: Sixty Years of Photographs*, Aperture Monograph (Millerton, New York: 1976), p. 24.

as an art form, inspired in large part by Alfred Stieglitz, who directed, through his own images, writings, and galleries, the course of modern photography. His promotion of "straight," unmanipulated photography over the soft-focus pictorialism of the medium's origins profoundly influenced the work of both Strand and Adams. In turn, their photographs of the Ranchos Church served to establish the building as a seminal form in the iconography of twentieth-century photography.

In Strand's photograph *St. Francis Church, Ranchos de Taos, New Mexico,* 1930 (Plate 8), the squat bulk of the church rises into the rich tones of the clouded sky, the structure and atmosphere fused into a single, coherent construct. Adams' photograph of the church (Plate 9), dated 1929, but probably made after he viewed Strand's negatives, is a view of the front of the church that includes, with suggestive effect, the distant presence of Taos Mountain. The clarity and sharpness which so impressed Adams in Strand's work are present in the crisp delineation of the sky, mountains, and church in his own. Laura Gilpin's (1891–1979) platinum print *Ranchos de Taos Church,* 1930 (Plate 10), similar to theirs in intent, transforms the mass and volume of the church into an architecture of membranous fragility.

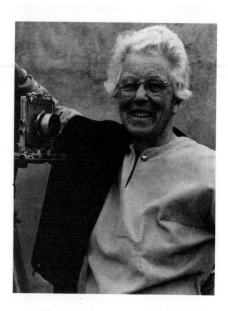

Laura Gilpin.

John Marin (1870–1953) spent two summers in New Mexico, in 1929 and 1930, by which time he had garnered a national reputation as an artist. He had exhibited ten paintings in the Armory Show, was in important museum and private collections, and had achieved critical and financial success exhibiting at Alfred Stieglitz' avant-garde "291" gallery in Manhattan. A year before his first visit, he had set forth his artistic goals in *Creative Art* magazine. "There will be the big quiet forms. There will be all sorts of movement and rhythm beats . . all seen and expressed in color weights. For color is life, the life Sun ashining on our World. . . ." Udall observes: "Three things mentioned in this brief exerpt had become familiar elements in New Mexico modernism: . . . big elemental forms, rhythmic movement, and sun-enlivened color. Thus, even before he thought of a southwestern trip, Marin was attuned to the forces so universally encountered here."[27]

Upon his arrival he explored the country in Dodge's automobile and made what were for him quite literal paintings of the landscape. He met and spent time with local artists that first summer, fishing and painting with Andrew Dasburg and Victor Higgins, and exhibiting with others. He had significant influence on the artists he met in Taos. Udall comments that,

During his second summer painting the New Mexico landscape

27. Udall, p. 124.

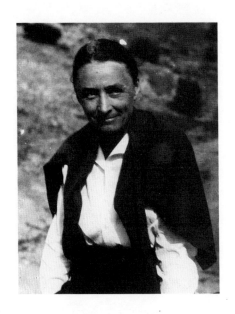

Georgia O'Keeffe in Taos in 1929.

Marin seemed to have gained confidence in his handling of often intractable southwestern subjects. One of his early paintings from the summer of 1930 was his *Back of Ranchos Church* [1930, (Plate 12)]. Although he painted several other versions of the little church outside Taos, this is his only view from the apse end—the west view from which O'Keeffe, Strand, Ansel Adams, and countless other painters and photographers have recorded it. . . . For Marin it must have been an exercise in restraint; he allowed the softly rounded contours to remain, . . . to slump gently toward the earth. . . . Marin has reserved his geometry for the sky and foreground. . . .[28]

Georgia O'Keeffe, another famous protégé of Alfred Stieglitz (they had married in 1924), came to New Mexico first as a visitor and ultimately to stay. (She and Rebecca Strand were guests of Mabel Dodge in 1929 when they suggested John Marin to her as a potentially interesting guest.)

The Ranchos Church impressed O'Keeffe like no other American building. Indeed, so strongly did she feel that she declared in her book, *Georgia O'Keeffe*:

> The Ranchos de Taos Church is one of the most beautiful buildings left in the United States by the early Spaniards. Most artists who spend any time in Taos have to paint it, I suppose, just as they have to paint a self-portrait. I had to paint it—the back of it several times, the front once. I finally painted a part of the back thinking that with that piece of the back I said all I needed to say about the church. I often painted fragments of things because it seemed to make my statement as well as or better than the whole could. And I long ago came to the conclusion that even if I could put down accurately the thing that I saw and enjoyed, it would not give the observer the kind of feeling it gave me. I had to create an equivalent for what I felt about what I was looking at—not copy it. I was quite pleased with the painted fragment of the Ranchos Church.[29]

Although she claimed not to have had significant contact with Marin in 1930, Georgia O'Keeffe's paintings of the Ranchos Church are quite similar to Marin's. In *Ranchos Church*, ca. 1930 (Plate 11), she emphasizes the sculptural form of the church, contrasting the angular geometry of the roof line with the undulating, feminine quality of the structure. She creates an image which is vaguely representational, with its correctly proportioned forms and subtle shadows, while conveying a somewhat surrealistic mood through the elimination of detail and projection of the church into a plane somewhere between earth and sky. By suppressing everything that gives the church context, O'Keeffe has created a nearly abstract organic mass. And by stripping it of context, an unexpected, perhaps deliberate, consequence results: the church is transformed into a distant and receding enigma, a silent riddle.

28. Udall, p. 131.
29. Georgia O'Keeffe, *Georgia O'Keeffe*. (New York: Viking Press, 1976): n.p.

Marin's watercolor (Plate 12), whose low-keyed palette is similar to that of O'Keeffe's oil, lacks its rich tonal quality. Geometric shapes frame the building, creating rhythm and movement in the space surrounding the church. Even the sky, only partially painted, is a compositional device. The entire area around the church, with its linear motifs and geometric forms, is energized by a circular movement which carries the eye around the building. The vitality and spontaneity in Marin's *Ranchos* is matched only in Victor Higgins' painting.

Victor Higgins (1884–1949) was an artist who arrived in New Mexico in 1914 and became a member of TSA. Although traditionally trained, he was influenced by modernist ideas and adopted techniques he encountered in the writings of art critics and theorists and of modernist artists who visited Taos. In his landscapes of the 1920s he demonstrated his tendency toward abstract geometric relationships. Marin's influence on Higgins is well known, and Udall points out that Higgins' *Ranchos Church*, ca. 1933 (Plate 14)

> demonstrate[s] a fluidity and spontaneity . . . that simply was not present in his pre-Marin work. . . . *Ranchos Church* . . . is a watercolor that is playfully experimental in both formal and symbolic terms. Into a compressed picture space Higgins has squeezed, simultaneously, apse and nave views of the little church, with spatial ambiguities heightened by the agitated sky above. . . . Higgins has deliberately upset normal space, scale, and visual unity . . . which brings to mind the cubistic fracturing of solids and spatial complexities Marin often imposed on his cityscapes.[30]

As in Marin's painting, the space surrounding the church is broken up into geometric planes which move in a circular pattern around the church. Like Marin, Higgins places a light wash over the church and uses subdued earth tones in the space surrounding the building.

Alexandre Hogue (1898–) is a realist painter who interpreted the Ranchos Church many times in many media—paintings, drawings, and lithographs—between the years 1926 and 1942. His *Pedro the Zealot*, 1933 (Plate 18), adopts modernist fragmentation and repetition. The repeated cross, from the small crucifix attached to his shirt button, to the fragment of the courtyard cross, to the cross adorning the church steeple, suggests his subject's connection to Ranchos Church and emphasizes his religious zeal.

The influence of O'Keeffe's fragmentation and abstraction is apparent in the photographs of several artists working in the modernist tradition. These artists concentrate on the play of light on the forms of the apse, ignoring the structure as a

30. Udall, p. 188.

whole and disregarding its religious function. The church—especially its walls and buttresses—becomes a touchstone which challenges the artist to see it in a fresh and personal way. Such a photograph is that by Will Connell (1898–1961), *Church at Ranchos de Taos*, ca. 1932 (Plate 15). A strong tactile impression of the hand-shaped, rough, and sandy adobe comes through to the viewer, and the sharply defined zones of light and shade anticipate the abstract masses adopted by painters in the 1940s.

Although it is apparent that a considerable number of photographs have been made from the same general perspective, it is also clear that each of these images has its own distinctive character. The photographs of both Robert Miller (1948–), *Ranchos de Taos Church*, 1979 (Plate 62), and Allen Carter (1933–), *Church, Ranchos de Taos—Sunrise #1, #2, #3*, 1975 (Plate 37), present the church in terms of the continuous changes that take place over time, recording the ephemeral moment. Their work presents not only a fragment of the building, but a fragment of time. Similarly, Charles Van Maanen's (1921–1984) color photograph *Cross and Tower*, 1982 (Plate 75), is only one of several hundred images in a carefully designed sequence which approximates a cinematic approach to an interpretation of the church.

Thomas Clyde's (1916–1985) 1937 photograph (Plate 16) explores the infinite subtleties of a small section of the church wall. The perspective in this photograph is similar to that of Connell's, but emphasizes the massive geometry typical of adobe construction. The raking light exposes the wavelike surface of the apse wall. In these photographs, and in those of Lynn Lown (1947–), *Untitled*, 1976 (Plate 38), and Jean Dieuzaide (1921–), *Ranchos de Taos*, 1981 (Plate 63), image is somehow almost entirely divorced from source.

The color photographs of Ruffin Cooper (1942–), *Taos Church III*, 1979 (Plate 54), and Arthur Taussig (1941–), *Taos, New Mexico*, 1976 (Plate 39) are, first of all, pure abstractions. The church has served only as the starting point for a reading which expresses the autonomy of the final image. Cooper dramatizes his subject with a greatly enlarged scale, by playing solid against void, and an almost theatrical intensification of color. Similar spatial construct and color appear in Taussig's photograph. Warmer in tone and sharper in contrast, the muffled borders and abstract masses of James O. Milmoe's (1927–) photograph *Ranchos de Taos Mission*, 1965 (Plate 55), give it a feeling of sculptural relief; the specific, tactile quality of the adobe surface and the swelling, hand-modeled wall become sculptural statements in their own right.

17

The source of these images is recognizable, but they are able to function quite independently of their origin. Representing as they do so small a fraction of the visual character of the subject, it is perhaps hardly important that the Ranchos Church be acknowledged as their source.

While many artists followed O'Keeffe's lead by abstracting fragments of the Ranchos Church, others reduced and simplified the structure, as she had done in her *Ranchos*. Some went beyond her to create almost minimalist abstractions. Robert Gribbroek (1907–1970), in his oil *Church, Ranchos de Taos*, n.d. (Plate 25), simplifies the planes of the church, but in a manner less undulating and fluid than O'Keeffe's. By comparison, his are erect, rigid, and formidable. And, unlike O'Keeffe, he introduces textural cloud forms, green vegetation, and a bit of landscape in the background. But the essential difference between O'Keeffe's work and his is in the use of color. Gribbroek's colors are stronger, brighter, and represent light and shadow less subtly. O'Keeffe's *Ranchos* radiates a strong white light, while Gribbroek's emits a softer one.

Form, scale, and design are the concerns of Ron Robles (1937–) in *Ranchos de Taos Church*, 1979 (Plate 73). As did O'Keeffe in her *Ranchos*, he has simplified form and color and cropped the church and pushed it forward to dominate the format. Rejecting color modulation, Robles uses a palette knife to give the church surface texture, the only variation in the pristine white surface except for two triangular shadows and a window. This reduction of form and color creates a feeling of tranquility and simplicity.

Walter Cooper (1939–) reduces the church to its most elemental geometric form in *Taos Memory*, 1982 (Plate 74). He depicts the church in a relentless, hard-edge style, without any trace of the undulating, soft quality in O'Keeffe's and Marin's work. Like Robles, Cooper sees the church in terms of its geometrical structure, but he uses flat bands of color which subtly change in value as they move from one plane to the next, creating a sense of distance and space. By intentionally choosing color values with a faded quality, Cooper underscores the title of his painting.

Grey Crawford (1951–) places geometric shapes in his untitled 1979 photograph (Plate 53) as counterpoint to the asymmetric, organic architecture of the church. In this work, the church floats, freed from its anchor by Crawford's use of a narrow range of cool tones as a sculptural, rather than merely descriptive, device and is pulled upward by the cloud formations behind it, giving the print a surrealistic quality reminiscent of O'Keeffe's *Ranchos*. The photograph is a study in pure form.

Gene Kloss, (1903–) arrived in Taos in 1925 from California, attracted by the space, the color, the distinct seasons and native cultures. It has been her home since. She chose the medium of copper etching for *Procession—New Mexican Church*, 1937 (Plate 13), in order, she has said, to capture the essence of both the dramatic architecture and the medium. Like Jonson, she worked in black and white, feeling that the use of color would lead her astray from her principal goal. The image is entirely modernist in style and mood. The strength and purity of the white church is contrasted with the dark, ominous sky. A procession dominates the open, uncluttered foreground. Like O'Keeffe, Kloss reduces the building to its essential form, and, like Marin and Higgins, she encircles it with rhythmic, symbolic iconography.

> I chanced to be by there [the church] on their Saints Day and saw this processional which I felt especially meaningful. It was long and encircled the church twice so that when it was coming around the second time, the end was still visible on the other side. Here were the descendents of the people who had built the church so many years ago, still using it, encircling it in their worship. I eliminated the grass at the base of the church to emphasize the "earthiness" of it and enhance the symbolism of the whole.[31]

After completing his studies at the prestigious Vienna Academy of Fine Arts in 1920, Joseph A. Fleck (1892–1977), faced with bleak postwar economic conditions in his native Austria, in 1922 accepted a loan from a friend in Kansas City for steerage passage to the United States. He arrived in Taos in 1924 after he chanced to see a traveling exhibition of the Taos Society of Artists in Kansas City. His son, Joseph A. Fleck, Jr., recalls that "He was greatly impressed by the quality of the work, and the western settings and the portraits of Indians reawakened his romantic boyhood visions of America. His decision to leave for Taos was made then and there."[32] Fleck's success as a portrait and figure painter was not interrupted by his move to Taos, where he continued his distinguished work. Though Fleck was not associated with the Taos Society of Artists, after World War II he joined the Taos Artists Association, which shared many of the goals of the earlier TSA.

As a painter he was a strict individualist, but as with many representational painters, Fleck's paint application and use of color became freer as he departed from the discipline of his art school years and fell under the spell of the unique light and color of northern New Mexico. He became close friends with Blumenschein, whom he considered his mentor, but his work was influenced as well by the work of Dasburg and other

31. Gene Kloss to Sandra D'Emilio, March 31, 1983, Museum of New Mexico Archives, Santa Fe.
32. Joseph Fleck, Jr., "Joseph A. Fleck, Sr.,—A Fine Sense of Poetry," *Southwest Art*, (January, 1981), p. 73.

modernists in Taos, as is evident in his lithograph *Winter in Taos*, 1935 (Plate 19). In this print he uses many abstract devices to depict the south side of the church from the ridge of Llano Quemado. By dividing his format into a geometric grid of horizontal lines, Fleck establishes receding planes, from the man and burro on the road in the foreground to the barren trees behind them, then to the mid-ground where the church is situated amidst a rhythmic array of rectangles representing the village, and finally to the abstract background of plains and mountains. Superimposed on these horizontal lines are strong diagonal lines that lead one's eye to the church. The houses and church are reduced to rectangular forms of light and dark, and the church, the largest mass of light and dark planes in the format, becomes the prominent subject.

When Fremont Ellis (1897–1985) arrived in Santa Fe in 1919 from his lifelong home in Montana, he was overwhelmed by the light and color he found. He was also impressed to discover that artists Carlos Vierra, Warren E. Rollins, Kenneth Chapman, Sheldon Parsons, Donald Beauregard, William Penhallow Henderson, Julius Rolshoven, B.J.O. Nordfeldt, Robert Henri, Marsden Hartley, George Bellows, Leon Kroll, Arthur Musgrave, Henry Balink, Theodore Van Soelen, and Gustave Baumann had either visited or settled permanently in Santa Fe by the time he arrived. Ellis was soon followed to Santa Fe by artists Willard Nash and Will Shuster of Philadelphia, and Jozef Bakos and Walter Mruk of Buffalo.

In 1921 these five men formed a group in Santa Fe, similar to the Taos Society of Artists, that they called "Los Cinco Pintores." Even though their backgrounds and painting styles varied considerably, they shared the goal of wanting to bring art to "the people" through exhibiting their works outside the museum setting. That goal notwithstanding, their first group exhibition was held at the Fine Arts Museum in Santa Fe. Los Cinco Pintores dissolved in 1926, but the artists remained close friends. In the 1920s several of them built adobe homes and studios next to one another on a road they named Camino del Monte Sol; they are now considered among the most beautiful homes in Santa Fe.

When asked why he painted *View of Ranchos de Taos Church*, ca. 1930s (Plate 22), Ellis replied, "I have always loved churches. However, the first thing which impressed me about Ranchos was not so much the church itself, but the setting and the background. I painted the subject as I felt about it. It's the impression, that's what I want to paint. I have a great love of nature and for the beauty of it."[33] His evocative work is in the romantic landscape tradition of early Western painters. As in

33. Robertson and Nestor, p. 95.

Blumenschein's painting, the south side of the church is bathed in late afternoon light. Unlike Blumenschein's painting, though, the vantage point is from a great distance. There is much atmospheric texture in the work, and the overall effect is impressionistic. The church glows against the dark greens of the trees and valley in the foreground and the dark purple and black mountains behind. Typical of his compositions, the bright areas are given spatial significance by juxtaposition against deep shadow areas. With thick impasto and loose brushwork, Ellis has created a peaceful, romantic work. As art historian Patricia Broder has commented, "The emotional and romantic quality which colors Ellis' attitude toward life is very evident in his painting. From the beginning he responded to the south-western landscape with an intense love, and his forceful works have always shown a direct response to a particular place and a particular time."[34]

In Siegfried Hahn's (1914–) *Clearing of Autumnal Afternoon Shower, Ranchos de Taos, New Mexico,* 1978 (Plate 49), the village, the church, and the landscape harmonize so complete-ly that they seem inseparable. Like Ellis, Hahn portrays the church in relation to its environment, and uses a rough-hewn, textural manipulation of paint that reveals his brushwork. More than Ellis, Hahn emphasizes "nature as a vast, intricate, often mysterious realm whose variety and unspoiled beauty sur-passed any of man's achievements,"[35] but he nevertheless intends that the church be the focal point of this impressionist landscape.

The color photographs of Douglas Keats (1948–), *Ranchos de Taos I, II, III, IV,* 1984 (Plate 79), and Bernard Plossu (1945–), *Ranchos de Taos, Winter,* 1977/78 (Plate 46), have both been printed using the Fresson process, a closely held family secret invented by Theodore Henri Fresson in the early part of this century. In addition to creating a moody, sumptu-ous print, Fresson is the only permanent, stable color process in use today. The three dimensionality and rich tones of the Fresson process, evident in these photographs, emphasize the impressionistic and poetic qualities of the Ranchos Church. Keats views the church as

benevolent and spiritual, a quiet, elegant symbol of the South-west. Though I have photographed it repeatedly from the same perspective in order to go beyond the myth of reality which photographs have the power to deliver, because of the power of the subject each photograph works as a single image. There is no absolute in life or in art, nor only one way to see the Ranchos church; each of these images reveals an ephemeral reality, one as valid as the next."[36]

34. Broder, p. 260.
35. Siegfried Hahn to Sandra D'Emilio, March, 1983, Museum of New Mexico Archives, San-ta Fe.
36. Douglas Keats to Suzan Campbell, June 9, 1986, Museum of New Mexico Archives, Santa Fe.

News of the burgeoning art colonies in Taos and Santa Fe spread, and during the 1930s artists continued to arrive in New Mexico seeking worthwhile subjects and a congenial working environment. The impressionist Wilfred Stedman (1892–1950) arrived in Santa Fe in 1934. He had met Henri and Sloan while studying at the Art Students League in New York and had heard of Santa Fe. Later, when he became Director of Industrial Arts at the Broadmoor Art Academy in Colorado Springs, he made frequent trips to New Mexico to paint with Couse, Blumenschein, and Berninghaus. He and his wife Myrtle finally decided to make their home in Santa Fe, attracted in large part by the adobe architecture, particularly the homes built by Los Cinco Pintores. The Stedmans' books, *Santa Fe Style Homes* and *Adobe Architecture*, are considered authoritative on local architecture.

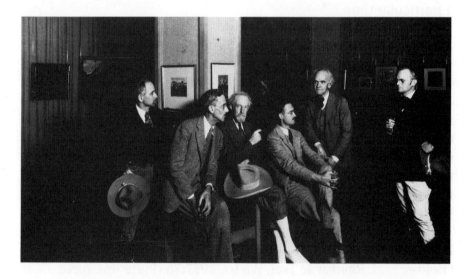

An informal meeting at Santa Fe's La Fonda art gallery, 1933, left to right: Carlos Vierra, Datus Myers, Sheldon Parsons, Theodore Van Soelen, Gerald Cassidy and Will Shuster.

To Stedman, Ranchos Church was the perfect example of what he loved about adobe architecture. In his painting, *Ranchos Mission*, ca. 1946 (Plate 20), Stedman emphasizes the flow of the massive back of the church. His use of light—in the sky, the clouds, and to highlight the church—creates a halo effect, and, as in Berninghaus' painting, the predominant feeling is one of peace and reverie. His figures leisurely passing the church, while much less exotic or striking than Blumenschein's, are still an important part of this dreamlike work. Stedman once said of the church that it exemplified the sincerity and simplicity, the organic character of structural design that allowed expression according to its function.[37]

As an artistic movement, surrealism took definite shape in 1924 with the First Surrealist Manifesto published by French poet André Breton. To a surrealist, the real world is not

37. Mrs. Wilfred Stedman to Sandra D'Emilio, March, 1983, Museum of New Mexico Archives, Santa Fe.

22

what the eye perceives, but exists in the realm of the unconscious. Objects are given new meaning by their juxtaposition in surprising and unexpected ways.

Surrealism found its way to the United States in the 1930s and not long after to the art colonies of northern New Mexico. Thomas Benrimo (1887–1958), an artist influenced by surrealism, moved to Taos in 1939. Born in San Francisco, he was largely self-taught, though he did study briefly at the Art Students League. The 1906 San Francisco earthquake destroyed his family home and all his drawings and papers, and he moved with his family to New York City to start over. Despite a serious case of tuberculosis, which afflicted him well into his forties, he was able to work as an illustrator and theatrical set designer. In 1939, at the height of his successful career as a commercial artist and as a brilliant teacher at the Pratt Institute, he and his wife Dorothy left New York for Taos, where he began an experimental phase in his work.

He had lectured at Pratt about the liberating effects of surrealist methods on the creative subconscious, and for the next decade Benrimo incorporated surrealistic devices into his work. In his drawing *Fiesta, Ranchos de Taos*, 1942 (Plate 21), the church appears to be floating in space. In front of it, also floating in the desert landscape, are a carousel and a group of people. The two unrelated objects, the church and the carousel, create a mood of strange unearthiness. The dark, lacquered paper and the cartouche with the inscription in the center are reminiscent of Old World maps, contributing to the feeling of another place and time.

E. Martin Hennings (1886–1956) was yet another member of the Taos Society of Artists who studied at the Art Institute of Chicago. After graduating with honors in 1904, he went to Munich to study with Franz von Stuck, who was renowned for his role in the propagation of *Jugendstil*, the German version of Art Nouveau. While in Munich, Hennings renewed his friendship with Victor Higgins and Walter Ufer, fellow students in Chicago. By 1915, after the war broke out in Europe, he realized he must return to the United States. In 1917, Carter H. Harrison, Jr., former mayor of Chicago and an art patron, offered Hennings an expense-paid trip to Taos. Ufer and Higgins had accepted similar offers, and Hennings wanted to join an art colony, so he decided to accept. In 1921 he decided to settle there permanently and in 1924 joined the TSA.

Hennings' undated painting *Ranchos de Taos, Evening*, (Plate 24), is uncharacteristic of his work, which is basically conservative in nature. The dark, closed church, contrasted with

23

the only light in the painting, which comes from behind the church; the deep shadows and the wall between the church and the shrouded figures passing by; and the pale moonlight washing the scene create an air of ominous mystery. While Hennings was not a surrealist, surrealistic influences are apparent in the painting. Hennings was not dogmatic about his work. He said of art that

> [it] must of necessity be the artist's own reaction to nature and his personal style is governed by his temperament, rather than style modeled through the intellect.... I believe in an individual-creative interpretation of my subjects—design and originality are dominant qualities of my work.[38]

Emil Bisttram (1895–1976) portrays the church in the moonlight in his *Ranchos de Taos Church—Night*, 1974 (Plate 44). Bisttram's light is not focused but pervades the entire painting. The church appears to rise from the snow-covered ground like a specter. The ghostly light emanating from the front door of the church creates a halo around the building itself. A small, lonely, phantasm-like figure stands in front of the open door, dwarfed by the building and the large white cross in the courtyard. This discrepant scale emphasizes the dreamlike quality of the painting.

Barbara P. Van Cleve (1935–) photographed the church in color at night, achieving an effect close to that of Bisttram's. Of her photograph *Big Dipper over St. Francis of Assisi Church at Ranchos de Taos*, 1981 (Plate 59), she has said,

> I had gone up to Taos to watch the Christmas Eve ceremonies at Taos Pueblo and had planned to photograph the Church at night.... The farolitos were on the rooftop edge in preparation to be lit for Midnight Mass and I wanted to photograph that light (and color) in conjunction with the light (and color) of the mercury arc street lights that illuminate this side of the Church at night. I was looking for something unusual in color to happen—I hoped. I had not dared to hope that the stars would be recorded on the film as stars and not as "star tracks." One of my real pleasures in this image is that the viewer can clearly see the Big Dipper ... suspended above and behind the Church.... And the Big Dipper adds the ultimate touch of symbolism: full and waiting on this Christmas Eve over one of the most beautiful examples of the Spanish Colonial Mission churches in the Southwest.... I was privileged to see this and to be able to make an image that would convey much of the real experience as well as a symbolic experience.

Robert Brewer's (1950–) *Lighting the Luminarias*, 1975 (Plate 43), is photographed at late dusk. An aura emanates from the church, and the presence of fiesta participants is suggested by the light made by torches or candles, and of

38. Broder, p. 260.

luminarias, small bonfires placed around the church. The hour, on the edge between day and night, and the visual absence of figures we know to be there, create the surrealistic feeling of the photograph.

John Nieto's (1936–) moonlit scene is highly surrealistic and expressionistic. *Ranchos de Taos Church*, 1980 (Plate 60), includes a ghostly orange figure, which contrasts strongly with the blue of the church. With a long, black shadow, this figure appears to be more alone and mysterious than Bisttram's figure. The silver foreground of the silkscreen print gradually blends into the blackness of the night, emphasizing the unearthly aspect of the image. Explaining his choice of a night scene, Nieto said it "emphasized the mystical quality of the church [and] expressed its serenity and peacefulness." The androgynous figure in the foreground represents "everyman." According to Nieto, "the painting represents three powers: the church, man, and God, which is symbolized by the moon which represents the universe or cosmos. The church is symbolic of the vehicle through which man maintains his spiritual connection to God. The moon is crying, it understands."[39]

Miguel Padilla (1954–) uses many surrealistic devices in *Ranchos Differente*, 1976 (Plate 41). By superimposing the piñon desert onto the courtyard wall in front of the church, he achieves an incongruous effect. The wall and desert become one. The scale reversal—the church is much smaller than the entrance—and impossible shadows under the church and cross lift it from the ground into a dream place illuminated by intense light. Padilla clearly stated his intentions when he wrote,

> I am most deeply incited by the European Surrealists' notion of free association artistically controlled. Among those I admire I'll refer to Salvador Dali and Rene Magritte. The startling clarity of the illogical/irrational imagery these two achieve is confoundingly inescapable. They implement an accomplished rational process to express intensely illogical conceptions, succeeding in making them appear disturbingly real. Clarity of forms, startling illogicality, and compositional tension are devices I utilize to create refreshing works intent on exploring the realms of imaginary extremes.[40]

Like Padilla, Douglas Johnson (1946–) paints a dreamscape and superimposes an illogical image on the courtyard walls. In *Church at Ranchos de Taos*, 1977 (Plate 48), he has reversed Padilla's scale, making the church huge and the wall and gate insignificant. The composition is symmetrical, implying order in the face of irrationality.

By superimposing and integrating a fish form on and into the rear of Ranchos Church, Susan Zwinger (1947–)

39. John Nieto to Sandra D'Emilio, Museum of New Mexico Archives, Santa Fe.
40. Miguel Padilla to Sandra D'Emilio, August, 1983, Museum of New Mexico Archives, Santa Fe.

forces the viewer to see these symbols and forms in new ways in her drawing *San Raphael Visits St. Francis*, 1982 (Plate 76). By employing multiple views, she presents her own imaginary world. Fish and fish scales are interchangeable with adobe walls, in a concept she calls "transmutation of materials." The fish symbolizes both Christianity and San Raphael, the healer who visits Ranchos in the form of a fish. "This drawing is about dream and thought," the artist has said. "I want to combine images in upsetting ways in order to force you to see in a new manner. There is no reason to expect your eye to be soothed by art; art is surprise, delight, and forces new vision."[41]

With the breakup of the modernist movement in the 1970s, a multiplicity of voices arose, and with them some of the most interesting and challenging perspectives of the church since the late 1930s. One of the more interesting manifestations of styles which have found a voice in this "post-modern" era is the new realism, whose objectivity seems total, and sometimes almost photographic.

Realist painters Paul Strisik (1918–), *Ranchos de Taos*, 1982 (Plate 72); Morris Rippel (1930–), *Ranchos de Taos*, 1974 (Plate 34), Michael Stack (1947–), *Days Passing*, 1982 (Plate 71); and James Kramer (1927–), *Ranchos de Taos Church*, 1979 (Plate 50), portray the church partially obscured by the buildings and foliage of the village of Ranchos. The church is not emphasized as subject, but is part of the overall scene. The fact that the church remains the focus of these paintings seems due more to its commanding presence than to artistic manipulation. Showing no signs of mannered exaggeration or overrefinement, these paintings are evidence of the fresh energy and imagination given realism in the past decade by many artists.

A Dada-like satire, Robert Ellis' (1922–) *Studio Bay with View of Valdez Valley #1*, 1976 (Plate 40), combines color photographs of the church and surrounding valley with precise pencil drawing. The image of the Ranchos Church is visible on a television set, but there is no one there to watch it; the chair is empty. A feeling of ambiguity and uneasiness is created by a vertical line which passes under the curved table top, around the room, and back to the television, making one feel as if he is in the room. Heightening the ambiguity is the Day of the Dead cart on the table. Though ominous, the pencil drawing of the cart seems unreal in contrast to the photographed church, so that no clear sense of reality can be established in the scene.

The painting of photo-realist William Acheff (1947–) comes close to *trompe l'oeil*, a French term meaning deception of the eye. For this still life, Acheff chose objects which he felt

41. Susan Zwinger to Sandra D'Emilio, August 1983, Museum of New Mexico Archives, Santa Fe.

related to a found photograph of the Ranchos Church taken around 1900. Every detail of each object is painstakingly rendered in this masterpiece of illusion. Acheff's goal is "to paint the silence which surrounds or permeates the objects and so emphasize the oneness of everything. Even though, in this case, the objects are related to the church and to the Hispanic culture, I try to find the absolute within the particular."[42]

Enclosed in a smooth skin of adobe and composed of clearly defined volumes, the church is a natural for artists working in an abstract expressionist style, as does Fritz Scholder (1937–), a major American painter admired for his vitality and personal intensity.

His formative years as an artist were spent in San Francisco as a student of Wayne Thiebaud, and with the lively group of artists there. Scholder's intensely expressionist work is noted for its surprising colors and arresting compositions. Critic Barbara Cortright further defines its power: ". . . more basic, still, than these is a certain mood, a dark cast of mind which the artists calls 'mystery' or 'magic.' It is this last, a personal confrontation between the artist and his creative sources, which aligns Scholder with expressionism, and makes possible the rest."[43]

The black, angular, cropped shapes of the buildings in the foreground of *Ranchos Church*, 1979 (Plate 58), contrast dramatically with the orange church in the background. Scholder establishes tension between the negative and positive shapes in the composition; at times the church appears to recede into the background, at other times the foreground appears to recede, creating a feeling of vague uneasiness. Through color and distortion of form, he creates an emotionally charged work.

Distortion of form is also integral to the composition of Harold Joe Waldrum's (1934–) *Primrose Light*, 1972 (Plate 36), but in a manner different from Scholder's. Waldrum exaggerates the forms of the church and allows them to fill the entire format. His concern is the relationship of abstract areas of light and dark and with being able to balance these richly painted shapes. The colored lines around the forms accentuate the flat areas of color, but he doesn't abandon subtlety in his expressionist palette. His work is formal, abstract, yet dramatic and expressive.

Kay Harvey (1939–) responded to the spirit of the church and the sensation of the moment in *Ranchos de Taos Church*, 1981 (Plate 61).

There was a storm in the background and that is why it is so dark behind the church. It was late Spring and very warm outside. The

42. William Acheff to Sandra D'Emilio, April, 1983, Museum of New Mexico Archives, Santa Fe.
43. Barbara Cortright, "Fritz Scholder," *Artspace* (Summer, 1983) p. 42.

light on the forms of the church made the building alive. The color of the church appeared to be very red and emphasized the unusual strength of its powerful image. It is alive like a mountain is alive and is a unique image of power. The colors I used helped express my feelings about the greatness and the sensual quality of the church.[44]

The form of the church in Harvey's painting is suggestive of the undulating image of O'Keeffe's *Ranchos*, but is cropped so that it reaches not only from side to side, but to the front edge as well. The dark mass above the bright red church seems to gently push the church forward, giving it an inviting immediacy, despite its imposing mass and form.

According to artist Frederico Vigil (1946–), the bravura colors of *Encuentro en Ranchos*, 1982 (Plate 70) symbolize the energy of the people who have kept the Ranchos Church a living vessel. The meeting between Los Hermanos from the moradas and members of the community was held to commemorate the dedication of the newly restored reredo. The important religious leaders of the area are gathered together for this event: the cacique from the Taos Pueblo (next to the Hermano mayor who is carrying the banner); and Father O'Brian, the former parish priest, at the end of the line on the left side. This merger is repeated in the cloud formation above the church. The church appears to pulsate like a heart as it rises from the multicolored ground. The distortions of the church, landscape and people in the procession accentuate the emotional intensity of the event. With its abstracted, simplified church encircled by symbolic figures, the composition is reminiscent of the modernist expressions of Jonson, Kloss, Marin, and Higgins, the major difference being Vigil's expressionistic palette.

Ranchos Steeple Dog, 1983 (Plate 57), by Bill Gersh (1943–), is part of a series of twenty-eight paintings entitled *Dog Dreams*. The series was conceived by Gersh as a vehicle for integrating and expressing his feelings about the church. Sometimes using paint directly from the tube, Gersh applies his vivid colors of pink, blue, green, and yellow to the canvas with spontaneous, quick brushstrokes, as Scholder does. Gersh includes only a fragment of the church, and expresses his relationship to it in a humorous and unique way through the personification of the dog, the distortion of form, and the arbitrary use of color.

The Ranchos Church is stripped of romantic illusion, and becomes merely an artifact—an echo of the past in an incongruent present, or a feature of daily existence—in photographs containing the church and automobiles or parts of

44. Kay Harvey to Sandra D'Emilio, August, 1983, Museum of New Mexico Archives, Santa Fe.

automobiles. Lou Stoumen's (1917–) *Ranchos de Taos Church, New Mexico*, 1978 (Plate 51), links the familiar apse of the church to the rounded apse-like rear of a school bus, and the long shadow of the bus with that cast by the church. Jim Shea's (1954–) *Untitled*, 1981 (Plate 77), extends the apse of the church and its history into the contemporary world of lowriders through the front and center presentation of an automobile bearing the license plate "CHICANO." Douglas Kent Hall's (1938–) *Ranchos de Taos Church*, 1976 (Plate 42), frames the church between the rearview mirror and body of a pickup truck.

Alex Sweetman (1946–) goes beyond objectivity in his photographs *Ranchos de Taos Church, Westside*, 1972/1982 (Plate 35), in which the undeniably modern features of the church, its gas meter and utility lines, are of central interest in the harshly lit, yet unrevealing, scene; Steve Yates (1949–) takes a similar approach in his erased and painted church, *Painted Church: Erased de Taos*, 1978/81 (Plate 52). In these photographs, the significance, and even the existence, of the church is challenged.

Edward Ranney (1942–) has documented the Maya and Inca architecture of Mexico and Peru and brings to his image, *Ranchos de Taos*, N.M., 1979 (Plate 56), the dignity of his other work. He made his photographic portrait of the church in the midst of a restoration program. This anti-romantic image has a transcendent reality—the church is stripped of its illusions, and of its romantic allure, but the integrity of the structure and its spirit remain.

These images of the Ranchos de Taos Church represent a broad range of expression, but they have by no means exhausted the subject. Now, as always, the quiet, profound force of Ranchos Church exerts its universal appeal and serves as inspiration to the many artists who come to northern New Mexico. And, as they continue to celebrate and honor this beautifully sculptured icon, these artists will add their contributions to an important legacy and to the artistic heritage of New Mexico.

29

IMAGES OF RANCHOS DE TAOS CHURCH
Plates

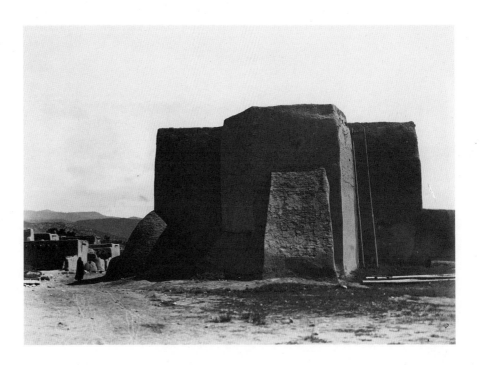

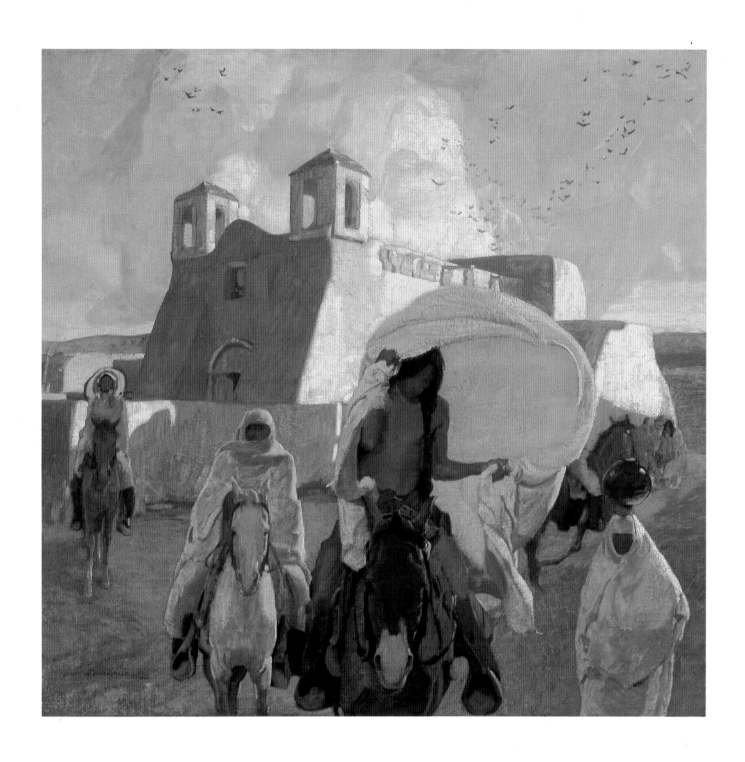

PLATE 2
Ernest L. Blumenschein
Church at Ranchos de Taos
before 1917

33

PLATE 3
Gustave Baumann
Church, Ranchos de Taos
1919

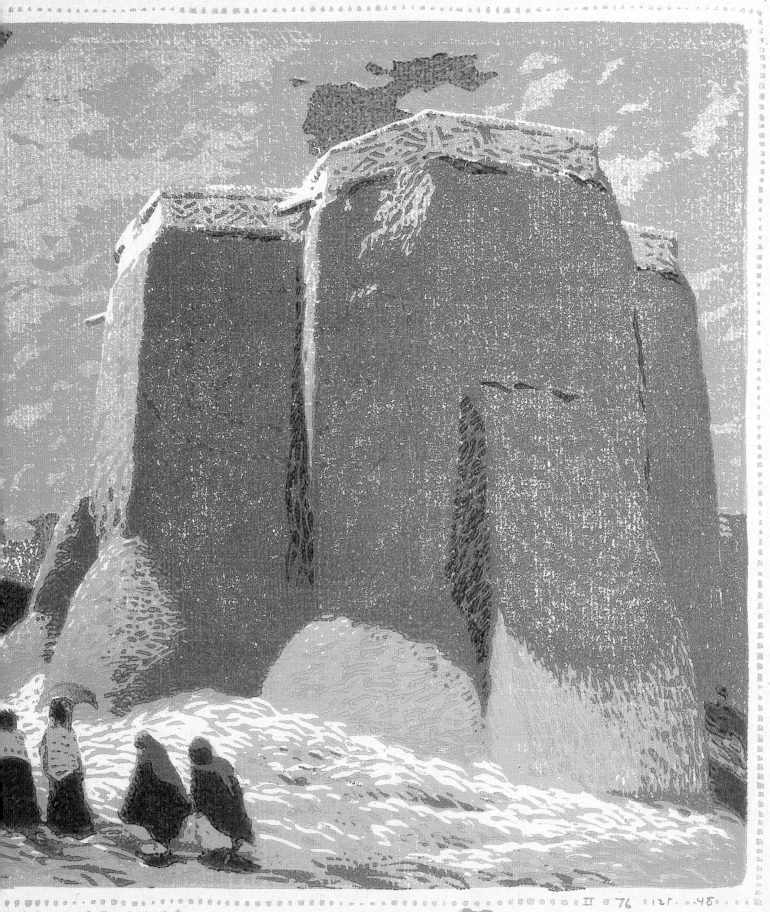

RANCHO DE TAOS

II · 76 · 125 · 45

Gustave Baumann

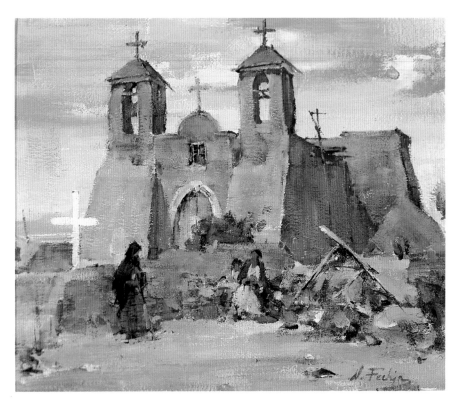

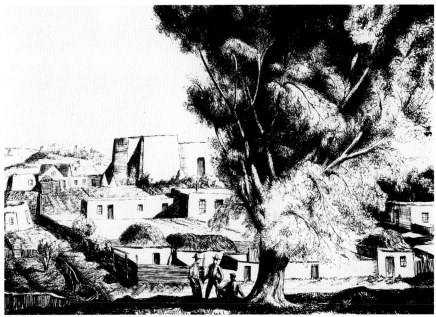

PLATE 4 (TOP)
Nicolai Fechin
Ranchos Church
1926–36

PLATE 5 (BOTTOM)
B.J.O. Nordfeldt
Ranchos de Taos
1925

PLATE 6 (RIGHT)
Oscar E. Berninghaus
Church at Ranchos de Taos
ca. 1920

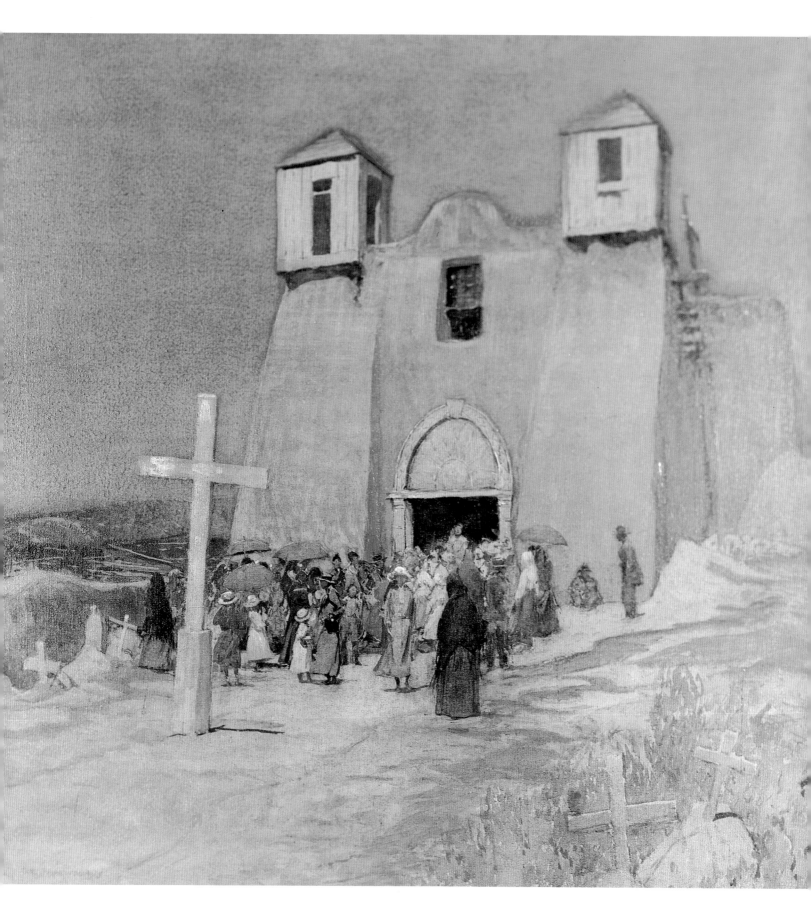

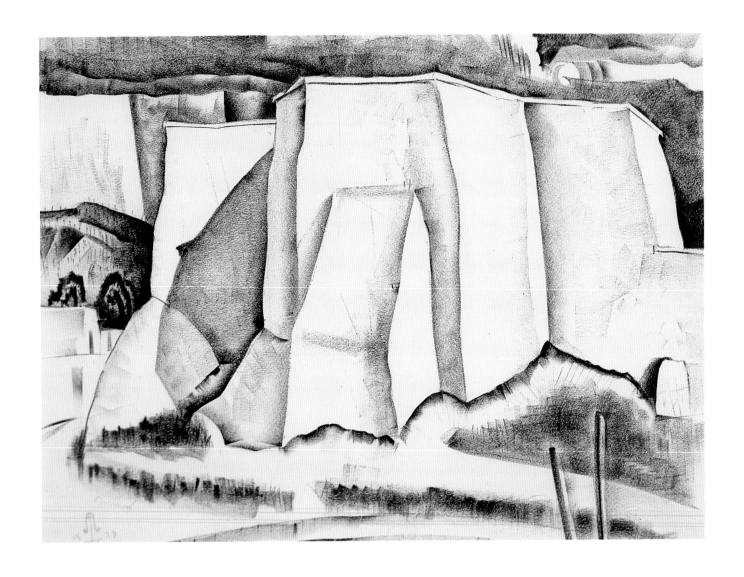

PLATE 7
Raymond Jonson
Ranchos de Taos Church
1927

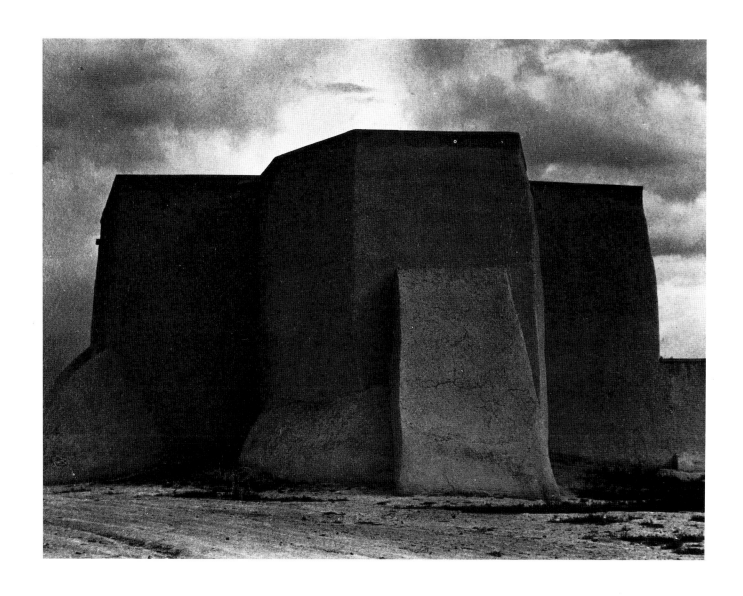

PLATE 8
Paul Strand
St. Francis Church, Ranchos de Taos,
New Mexico
1930

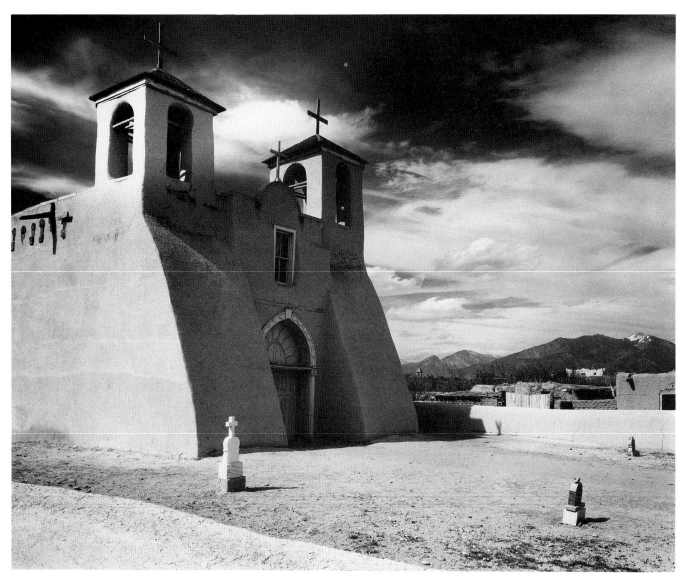

PLATE 9
Ansel Adams
Ranchos de Taos Church, Taos, New Mexico
1929

40

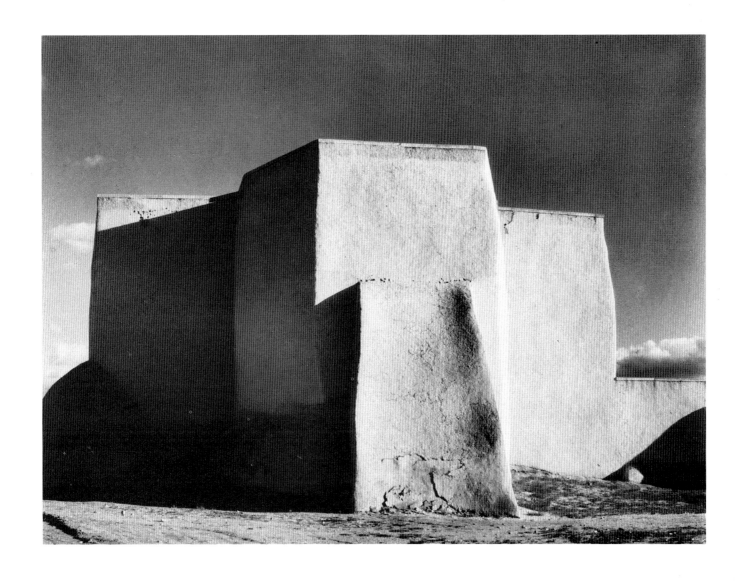

PLATE 10
Laura Gilpin
Ranchos de Taos Church
1930

The Ranchos de Taos Church is one of the most beautiful buildings left in the United States by the early Spaniards. Most artists who spend any time in Taos have to paint it, I suppose, just as they have to paint a self-portrait. I had to paint it—the back of it several times, the front, once. I finally painted a part of the back thinking that with that piece of the back I said all I needed to say about the church.

Georgia O'Keeffe, 1976

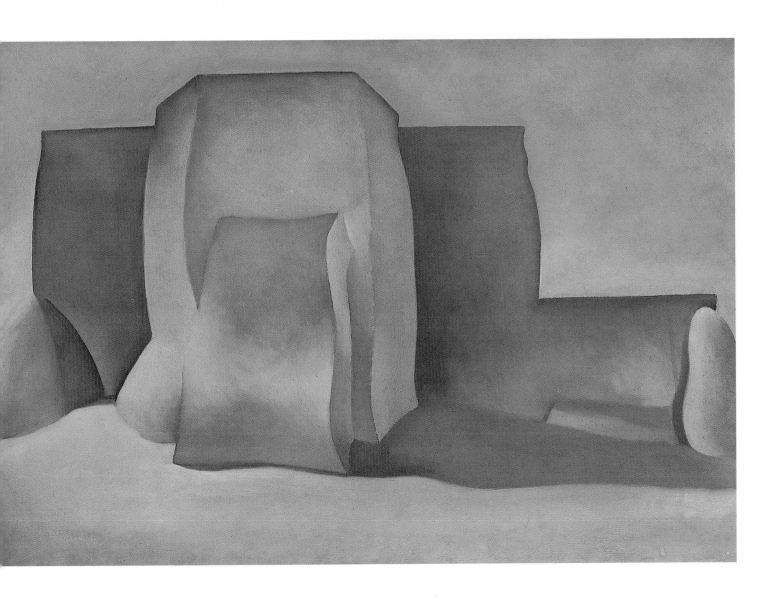

PLATE 11
Georgia O'Keeffe
Ranchos Church
ca. 1930

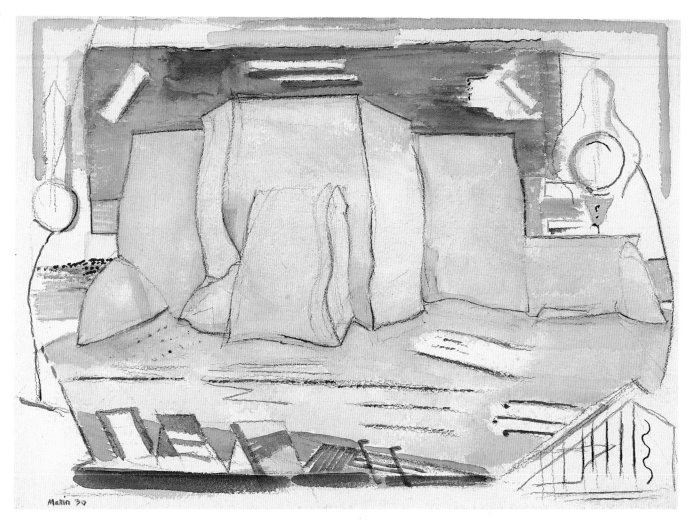

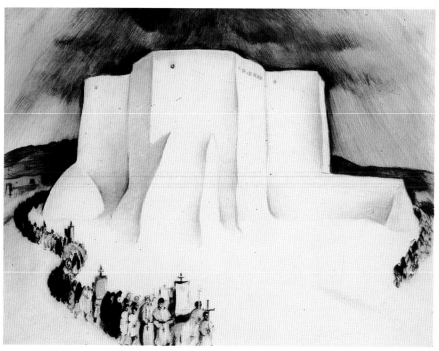

PLATE 12 (TOP)
John Marin
Back of Ranchos Church
1930

PLATE 13 (BOTTOM)
Gene Kloss
Processional—New Mexican Church
1937

PLATE 14 (RIGHT)
Victor Higgins
Ranchos Church
ca. 1933

44

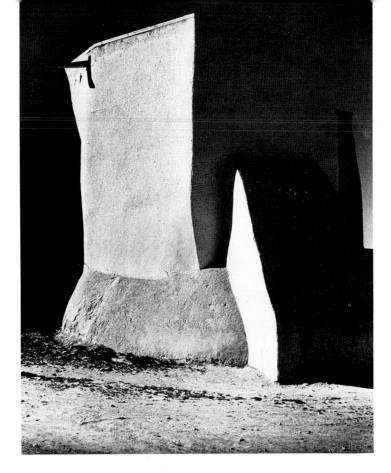

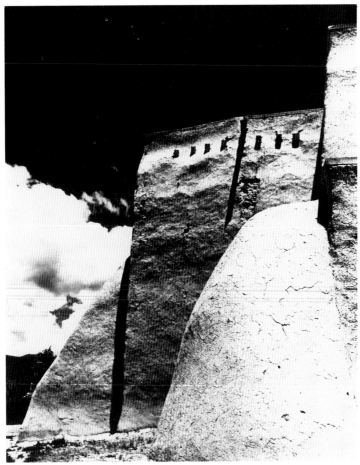

PLATE 15 (TOP)
Will Connell
Church at Ranchos de Taos
ca. 1932

PLATE 16 (BOTTOM)
Thomas H. Clyde
Untitled
1937

PLATE 17 (RIGHT)
Ernest Knee
Ranchos de Taos Church, NM
1939

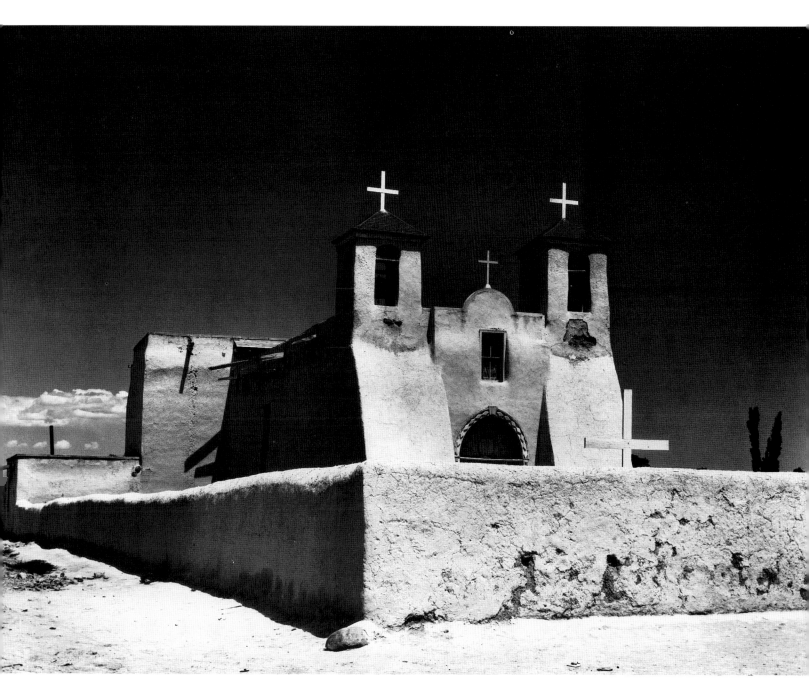

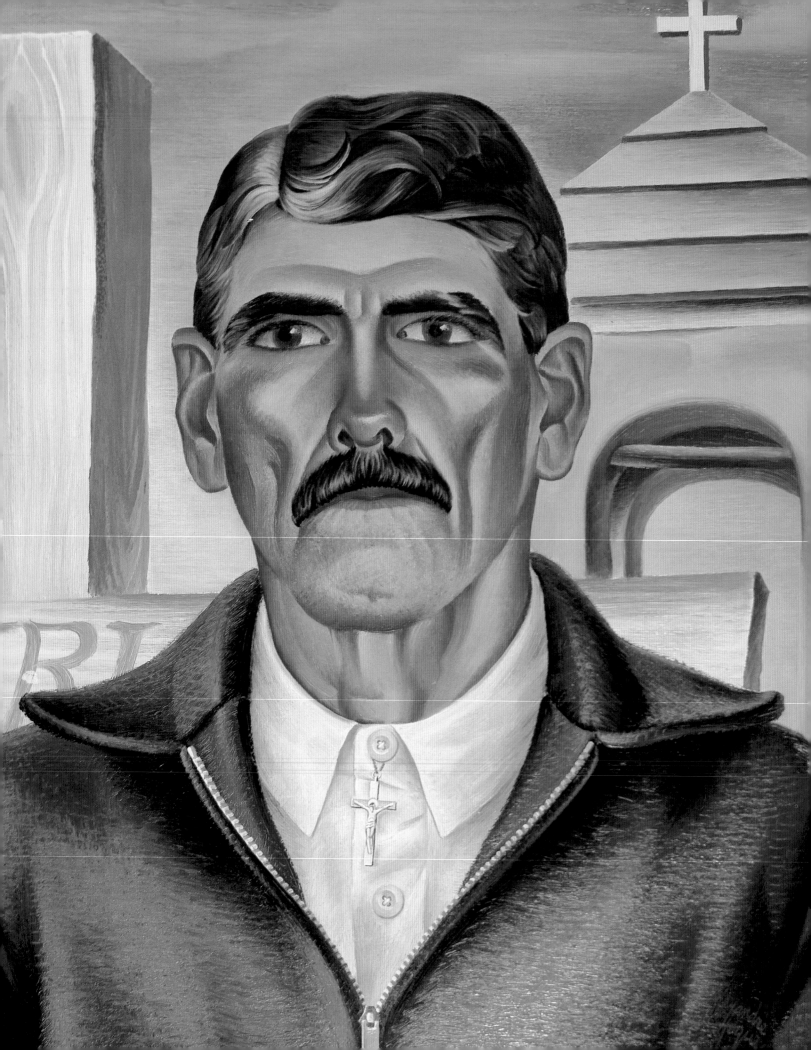

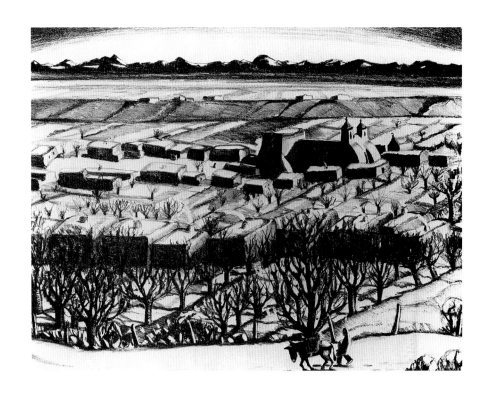

Those buttresses constitute a ready-made abstraction, an ever present challenge, a kind of outside-the-sanctuary place of silent visual worship or inspiration which kept drawing me back for more.
Alexandre Hogue

PLATE 18 (LEFT)
Alexandre Hogue
Pedro the Zealot
1933

PLATE 19 (ABOVE)
Joseph A. Fleck
Winter in Taos
1935

PLATE 20
Wilfred Stedman
Ranchos Mission
ca. 1946

50

PLATE 21 (TOP)
Tom Benrimo
Fiesta, Ranchos de Taos
1942

PLATE 22 (BOTTOM)
Fremont F. Ellis
View of Ranchos de Taos Church
ca. 1930s

PLATE 23
John Collier
Ranchos Church
1943

52

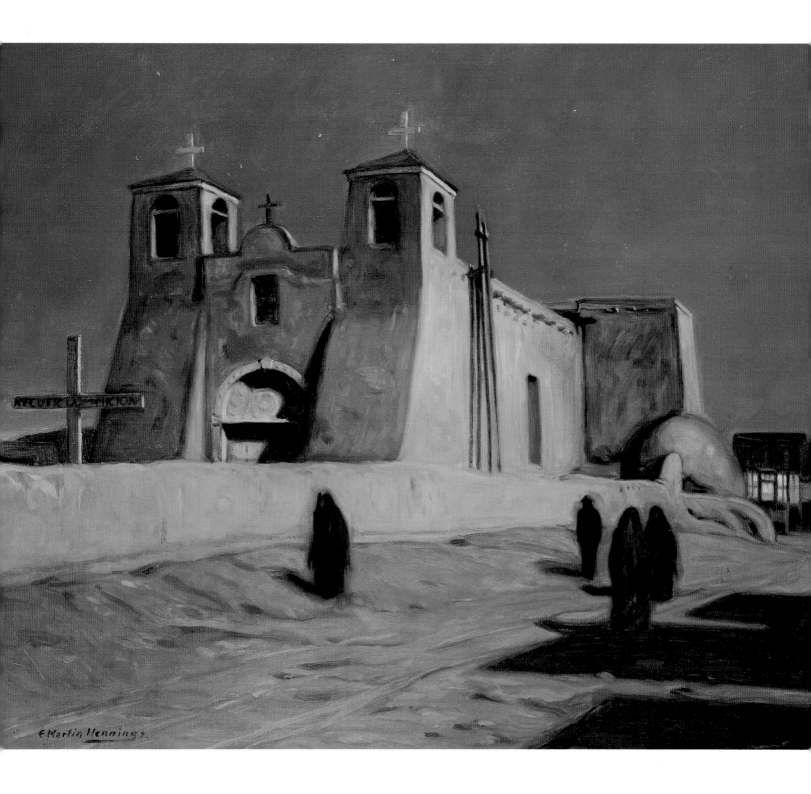

PLATE 24
E. Martin Hennings
Ranchos de Taos, Evening
n.d.

53

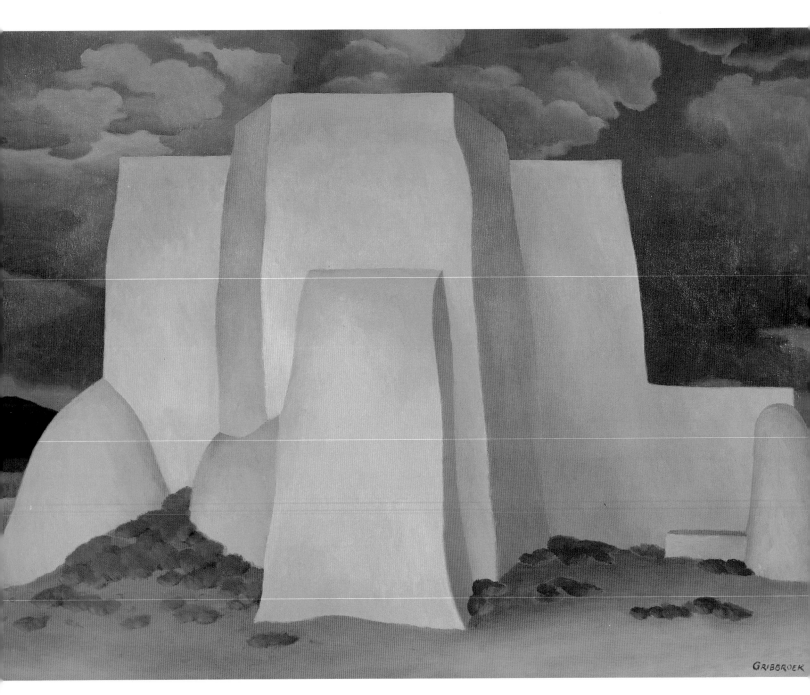

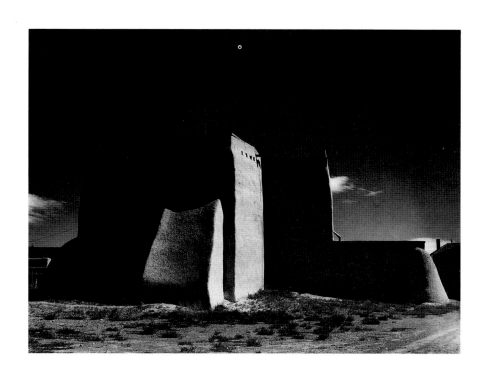

PLATE 25 (LEFT)
Robert Gribbroek
Church, Ranchos de Taos
n.d.

PLATE 26 (ABOVE)
Winter Prather
Ranchos de Taos
1947

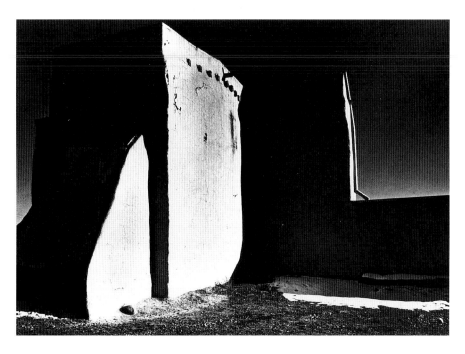

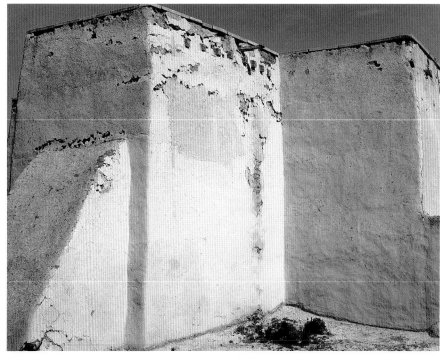

PLATE 27 (TOP)
Wright Morris
Adobe Church, Ranchos de Taos
1940

PLATE 28 (BOTTOM)
Dave Read
Ranchos de Taos, NM
1966

PLATE 29 (RIGHT)
Myron Wood
Elder at Ranchos de Taos
1964

56

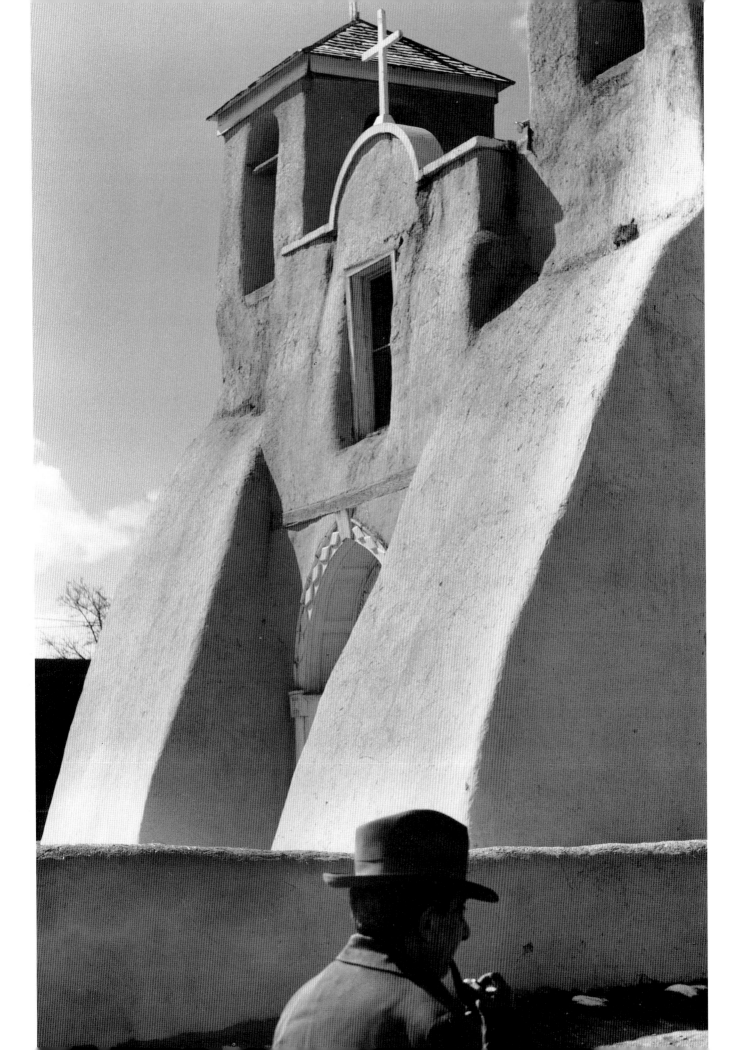

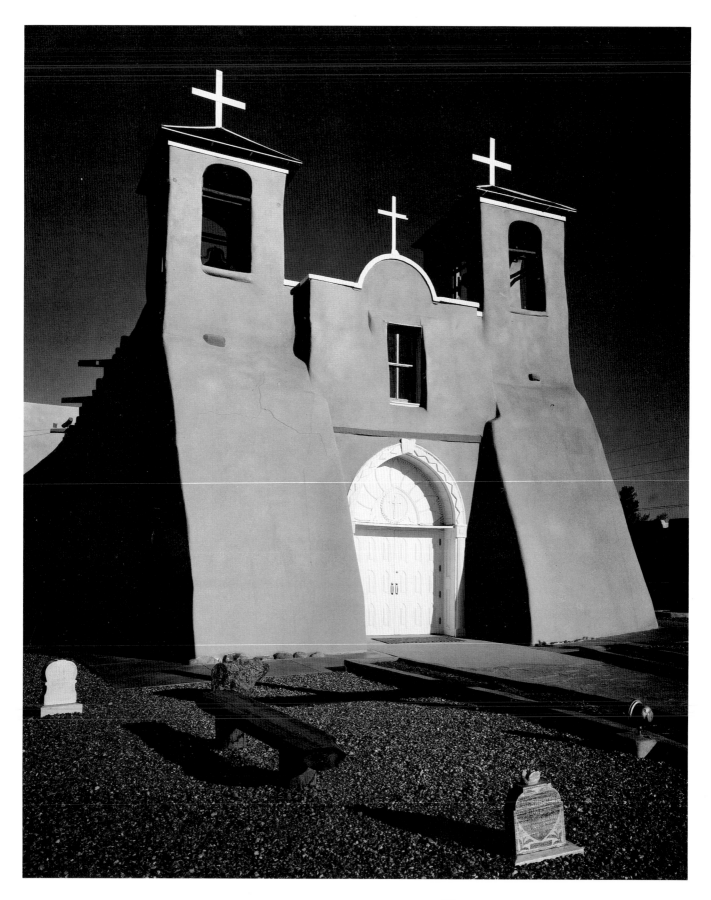

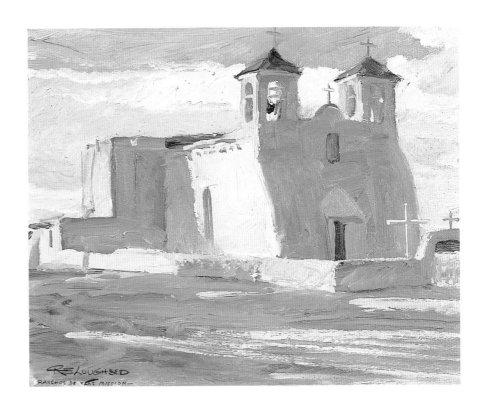

The first rays of desert sunshine carve an ever-changing excitement from the dominant facade at Ranchos de Taos. Some find a religious experience in the building. For a photographer, the beaming white portal between the adobe bell towers—the entirely simple face of a primitive church—creates a magnificent and exhilarating visual delight.
Morley Baer

PLATE 30 (LEFT)
Morley Baer
Mission Church, Ranchos de Taos
1973

PLATE 31 (ABOVE)
Robert Lougheed
Ranchos de Taos Mission
1971

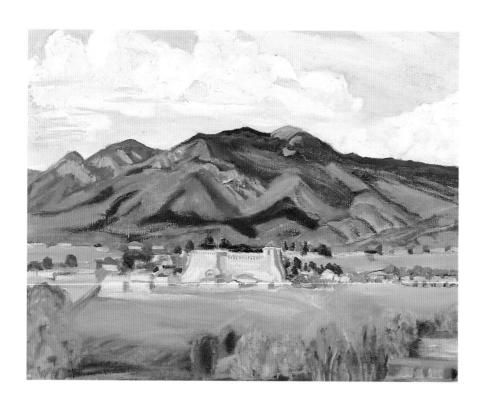

PLATE 32
Helen Greene Blumenschein
Ranchos Church
ca. 1970

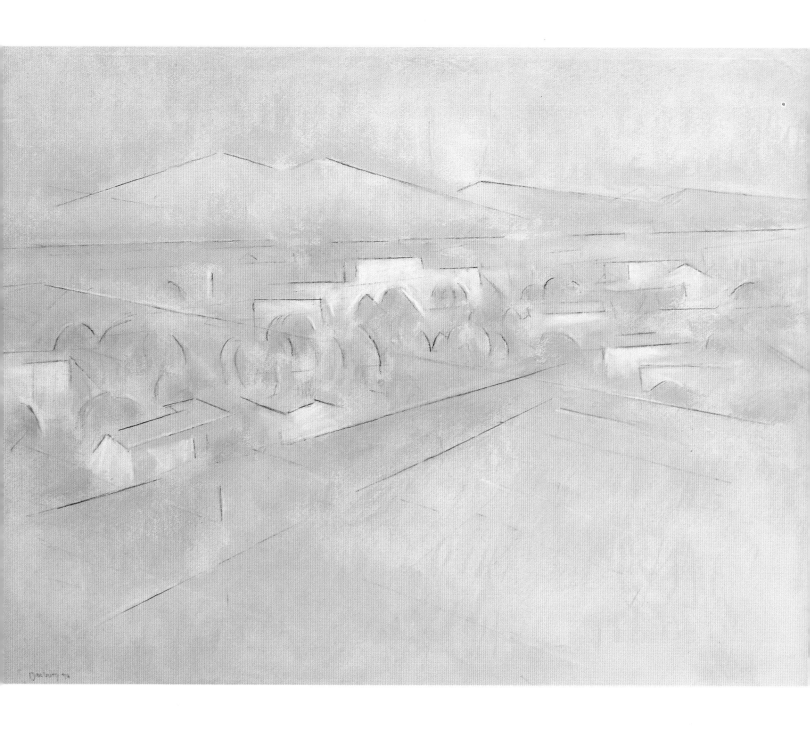

PLATE 33
Andrew Dasburg
Spring in Ranchos
1974

PLATE 34
Morris Rippel
Ranchos de Taos
1974

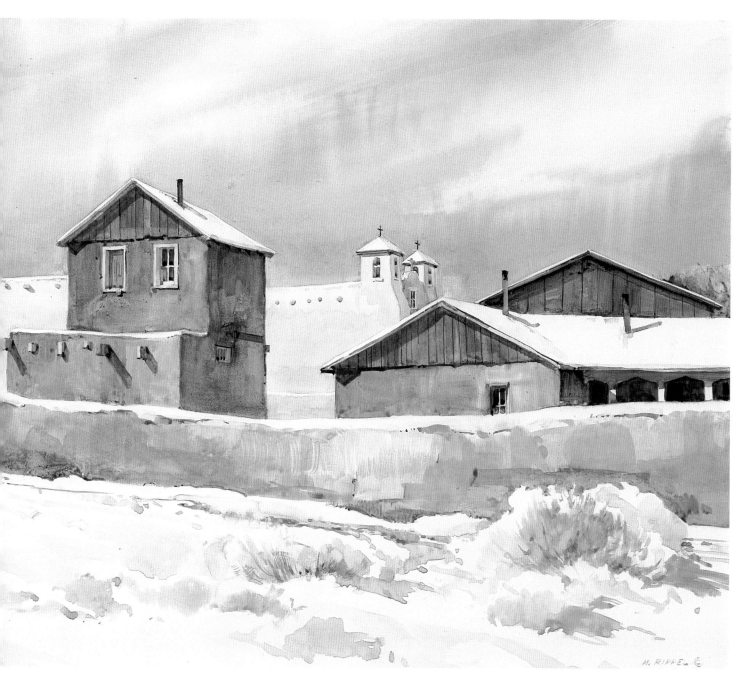

63

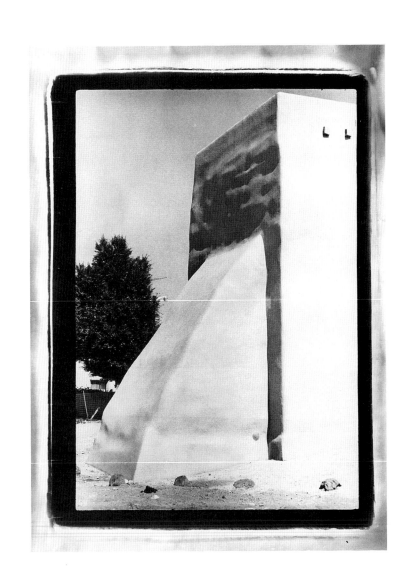

PLATE 35
Alex Sweetman
Ranchos de Taos Church, Westside
1972/1982

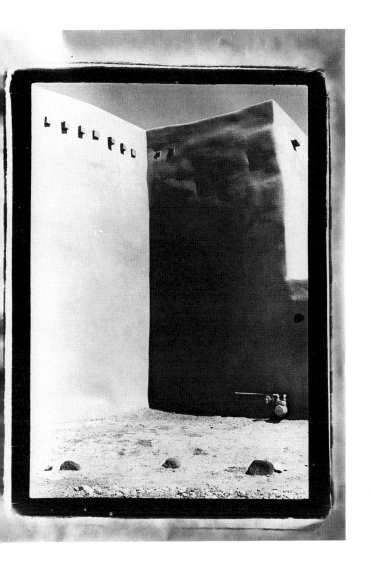

There is a beautiful place in the United States of America. It is between the two mountain ranges. This place is called "the cradle." Its people, the land, and its elements are special and peculiar. I find the genius of this place reflected in the churches.

Harold Joe Waldrum, 1982

66

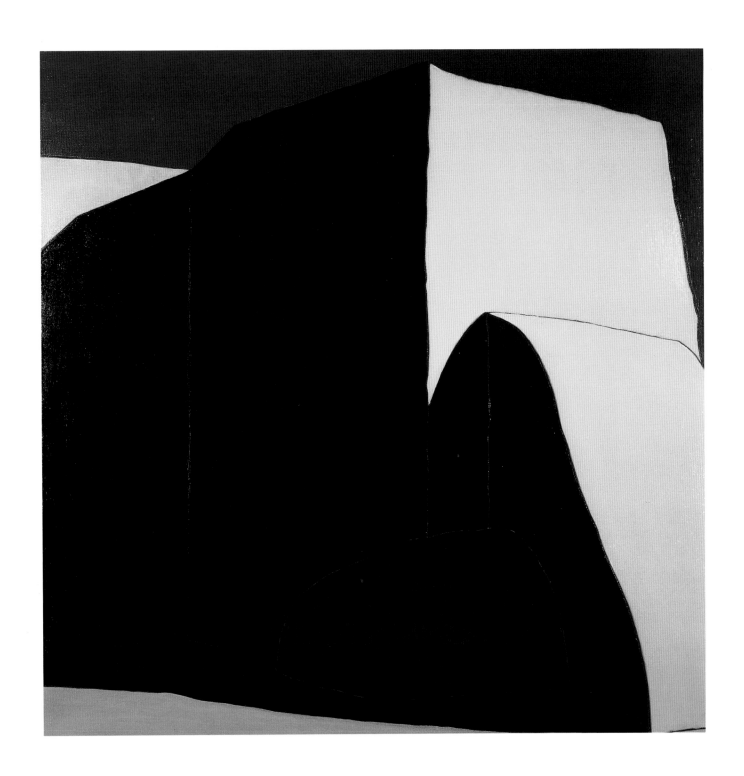

PLATE 36
Harold Joe Waldrum
Primrose Light
1972

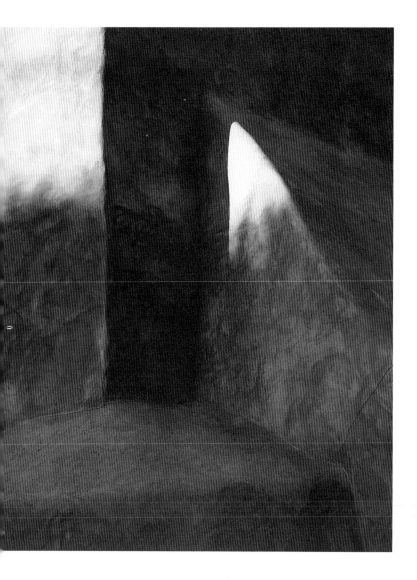 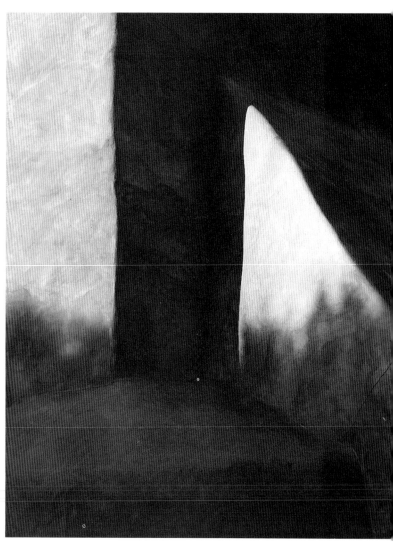

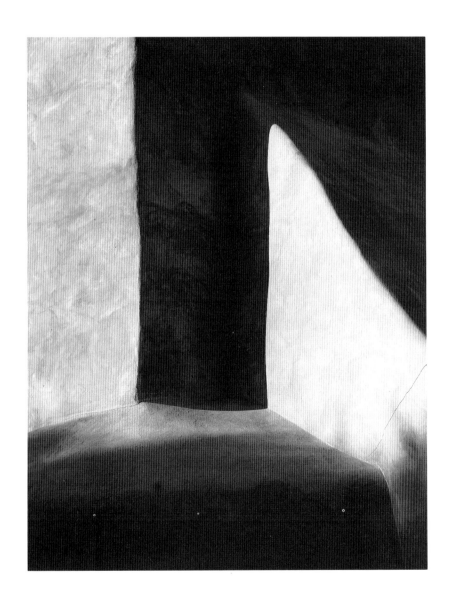

PLATE 37
Allen E. Carter
Church, Ranchos de Taos—Sunrise #1,
#2, #3
1975

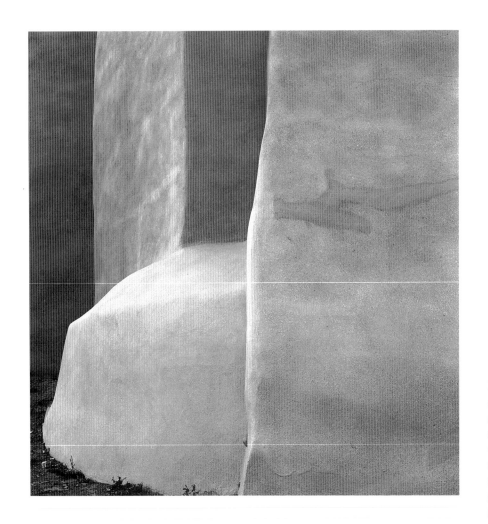

I was aware of the long photographic history of the Ranchos de Taos Church and I felt that a modernistic response was appropriate. At the time the photograph was made, my interests centered around investigating the ideas and limits of minimal art combined with exploring the sensuous possibilities of color photographic materials.
Arthur Taussig

PLATE 38 (ABOVE)
Lynn Lown
Untitled
1976

PLATE 39 (RIGHT)
Arthur Taussig
Taos, New Mexico
1976

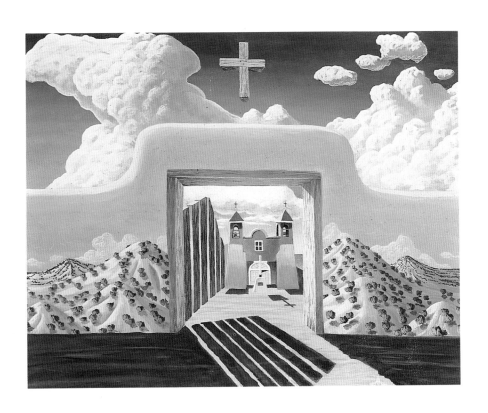

PLATE 40 (LEFT)
Robert M. Ellis
Studio Bay with View of Valdez Valley #1
1976

PLATE 41 (ABOVE)
Miguel M. Padilla
Ranchos Differente
1976

PLATE 42
Douglas Kent Hall
Ranchos de Taos Church
1976

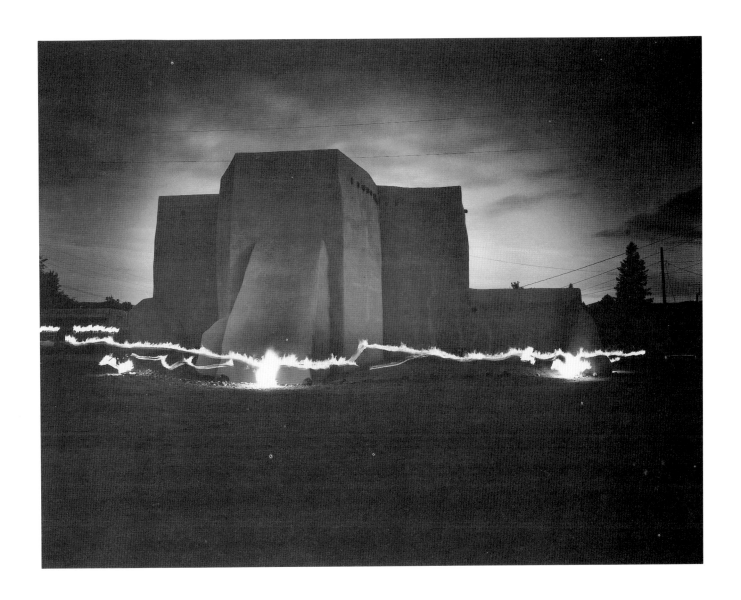

PLATE 43
Robert Brewer
Lighting the Luminarias
1975

75

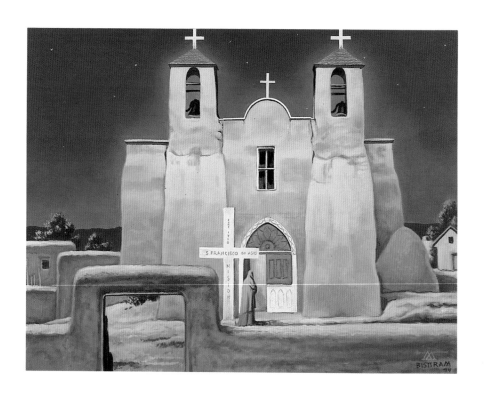

PLATE 44 (ABOVE)
Emil Bisttram
Ranchos de Taos Church—Night
1974

PLATE 45 (RIGHT)
Julia Oros Williamson
*Christmas Eve—St. Francis of Assisi
Mission, Ranchos de Taos, New Mexico*
1977

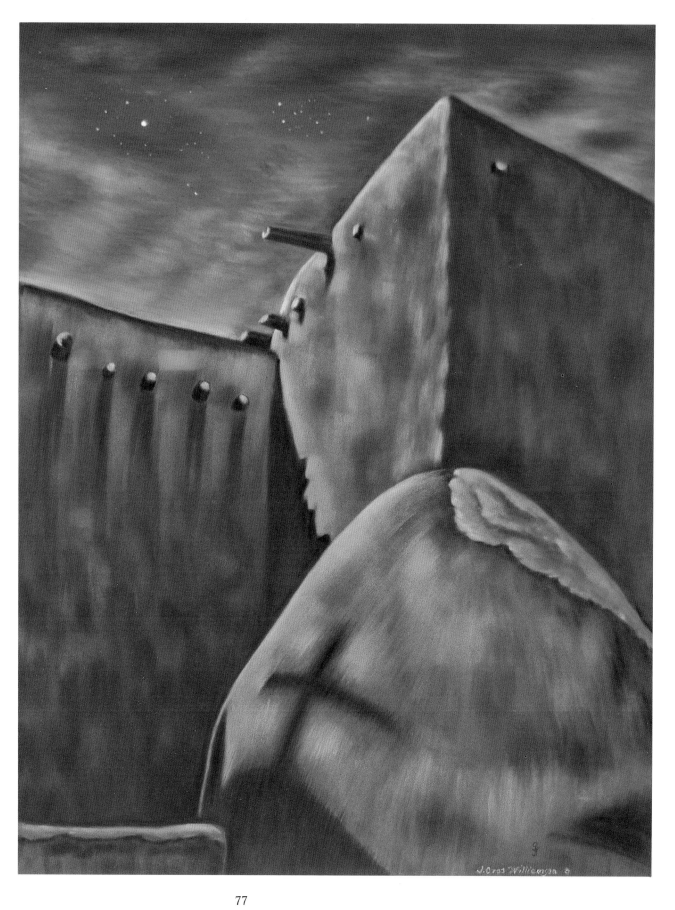

77

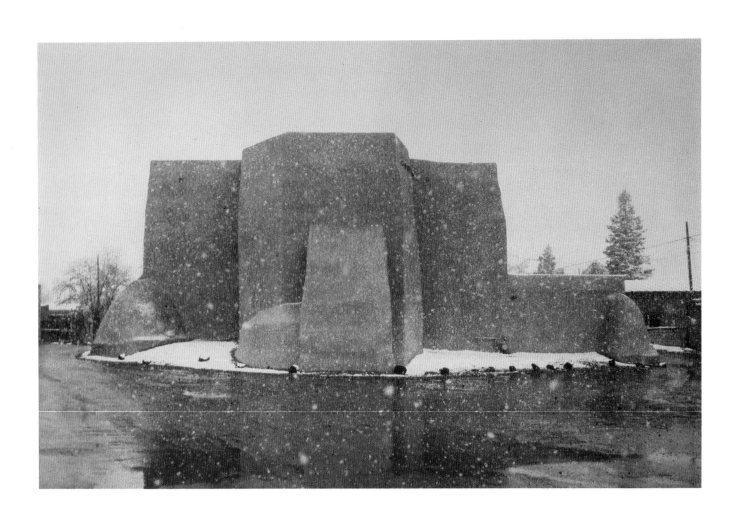

PLATE 46
Bernard Plossu
Ranchos de Taos, Winter
1977/78

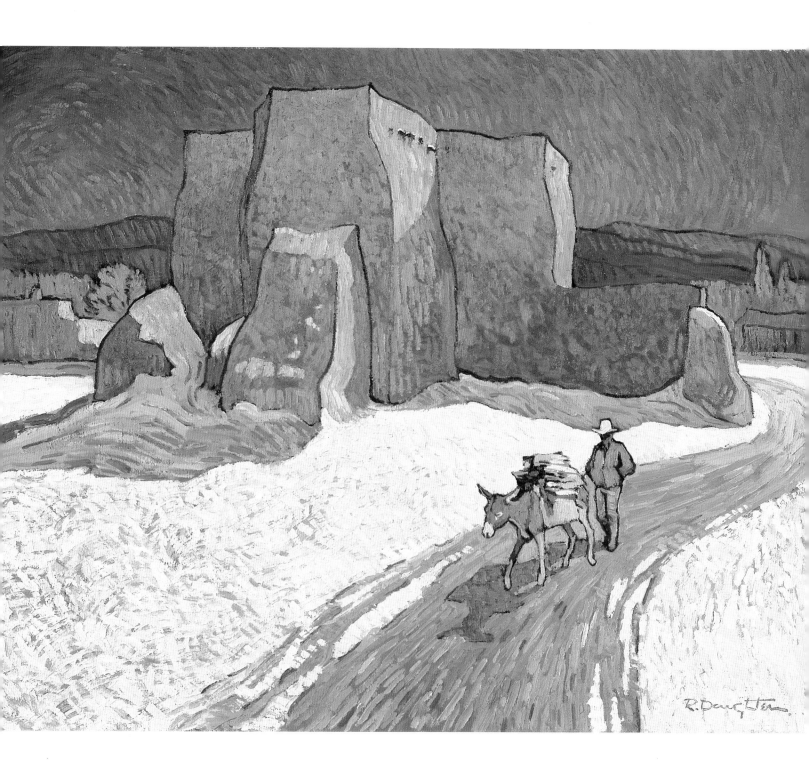

PLATE 47
Robert Daughters
Winter Reflections in Ranchos
1977

Since so many artists had painted the rear view of the church, I decided to portray the front. To create a dream-like aura, I painted a lavendar evening sky with pink and orange clouds, and lined the pathway with orange flowers on a blue field. The earthen lines of the architecture are echoed in the line of the mesas. Indian youths with rainbow wings plant prayersticks on either side of the gate.

Douglas Johnson

PLATE 48
Douglas Johnson
Church at Ranchos de Taos
1977

81

PLATE 49
Siegfried Hahn
Clearing of Autumnal Afternoon Shower,
Ranchos de Taos, New Mexico
1978

PLATE 50
James Kramer
Ranchos de Taos Church
1979

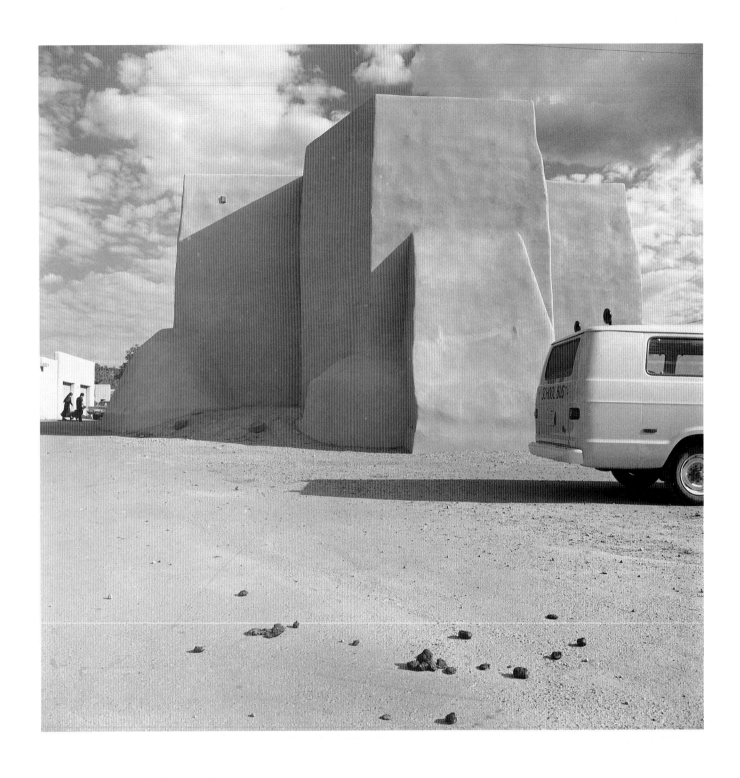

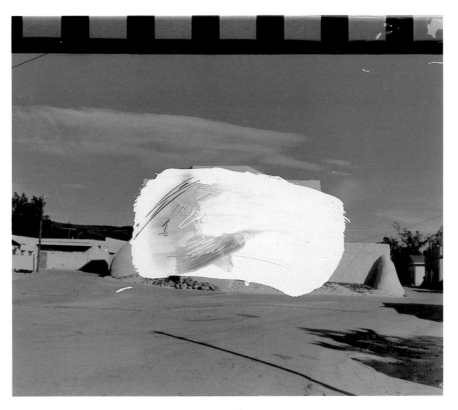

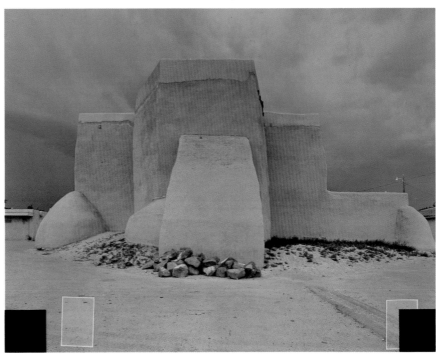

PLATE 51 (LEFT)
Lou Stoumen
Ranchos de Taos Church, New Mexico
1978

PLATE 52 (TOP)
Steve Yates
Painted Church: Erased de Taos
1978/1981

PLATE 53 (BOTTOM)
Grey Crawford
Untitled
1979

PLATE 54
Ruffin Cooper
Taos Church III
1979

86

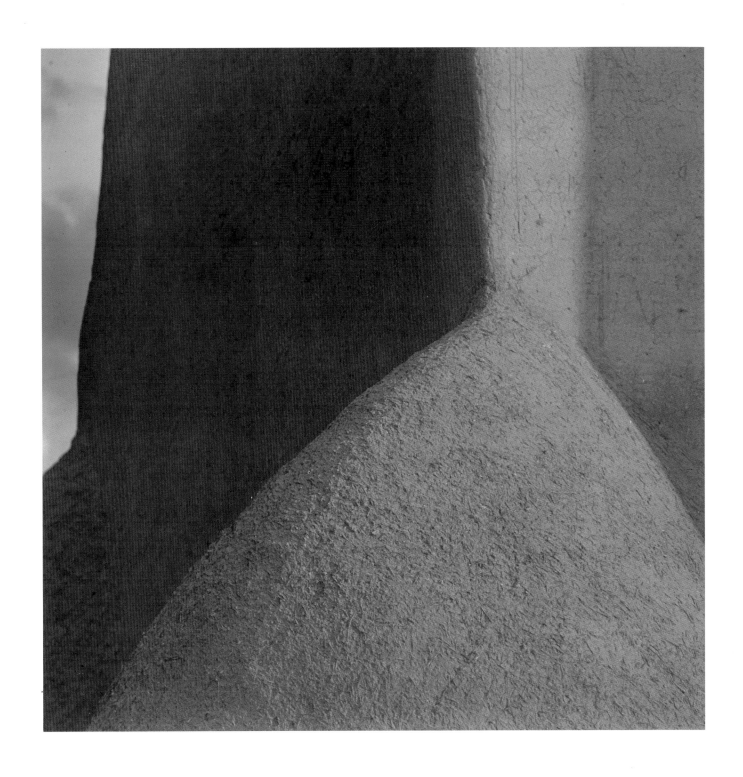

PLATE 55
James O. Milmoe
Ranchos de Taos Mission
1965

Photography is a poetic art because by showing us "this" it alludes to "that." A continual communication between the explicit and the implicit, the seen and the unseen. The proper domain of photography, like art, is no different from that of poetry: the impalpable and the imaginary. But revealed, filtered, by the seen.

Octavio Paz
from *The Instant and the Revelation*, 1982

PLATE 56
Edward Ranney
Ranchos de Taos, N.M.
1979

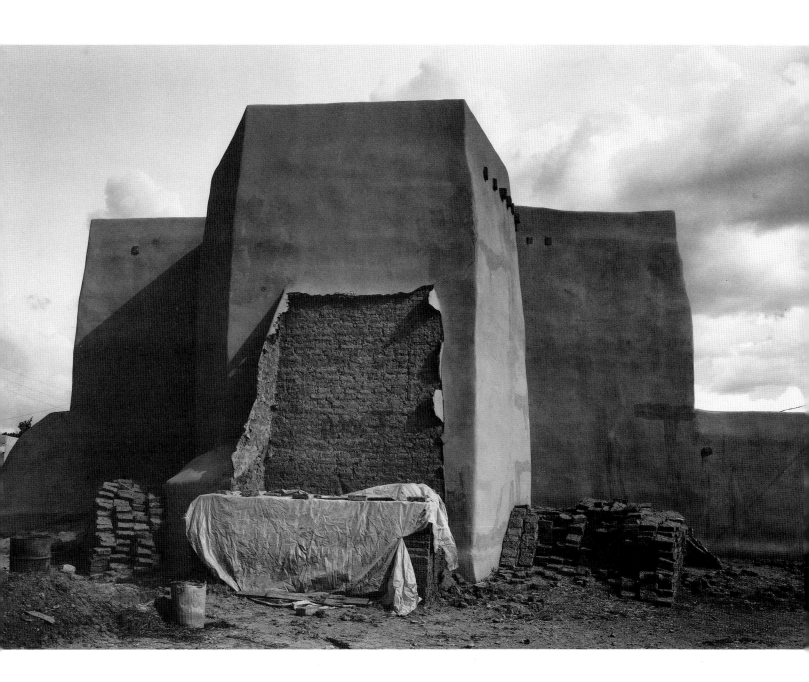

PLATE 57
Bill Gersh
Ranchos Steeple Dog
1983

90

PLATE 58
Fritz Scholder
Ranchos Church
1979

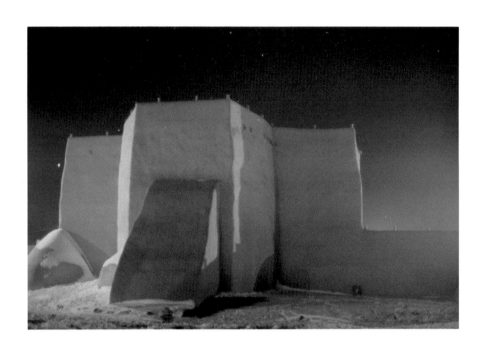

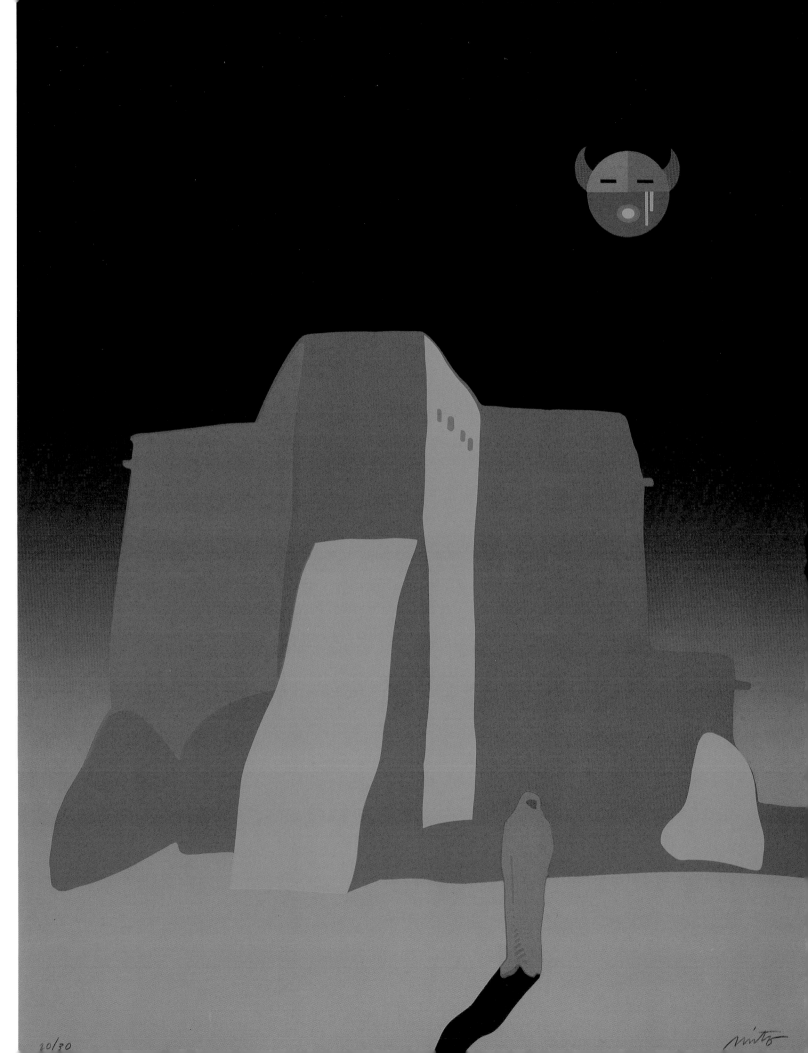

20/30

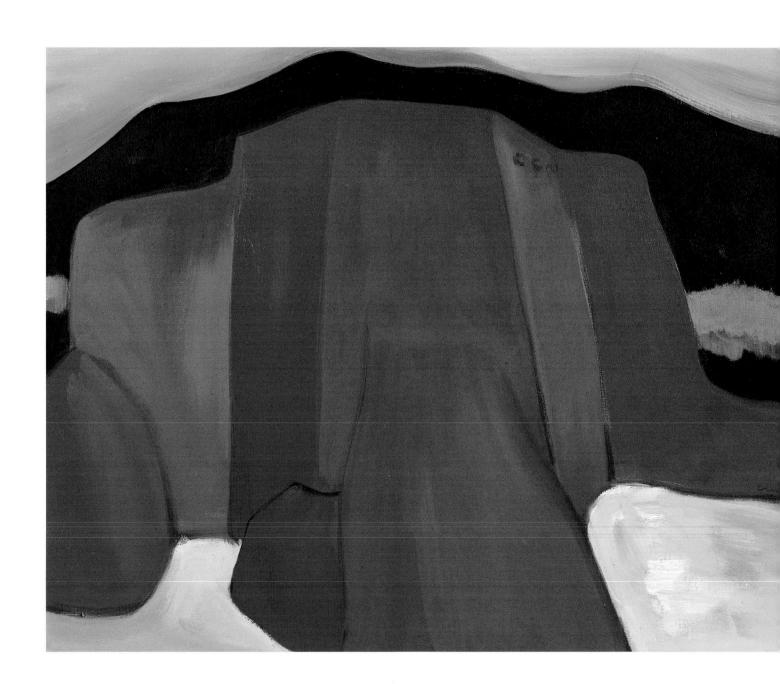

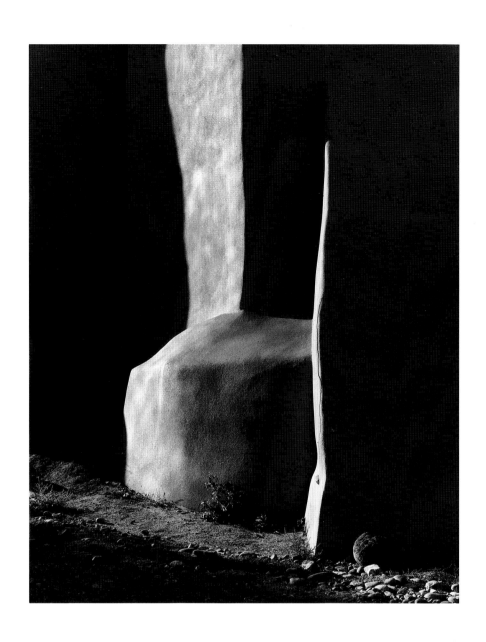

95

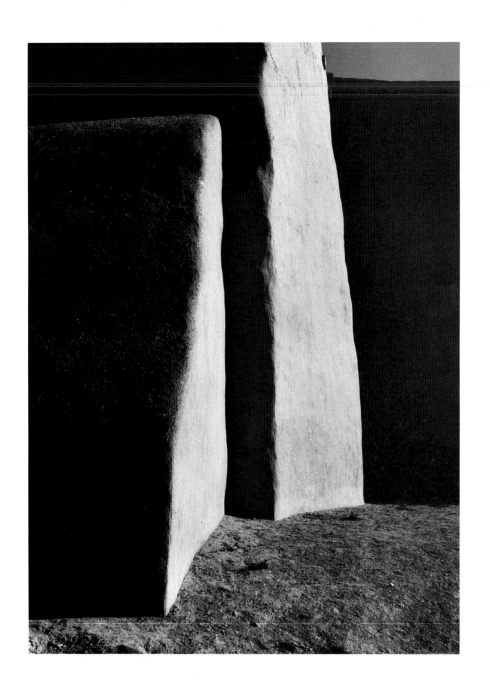

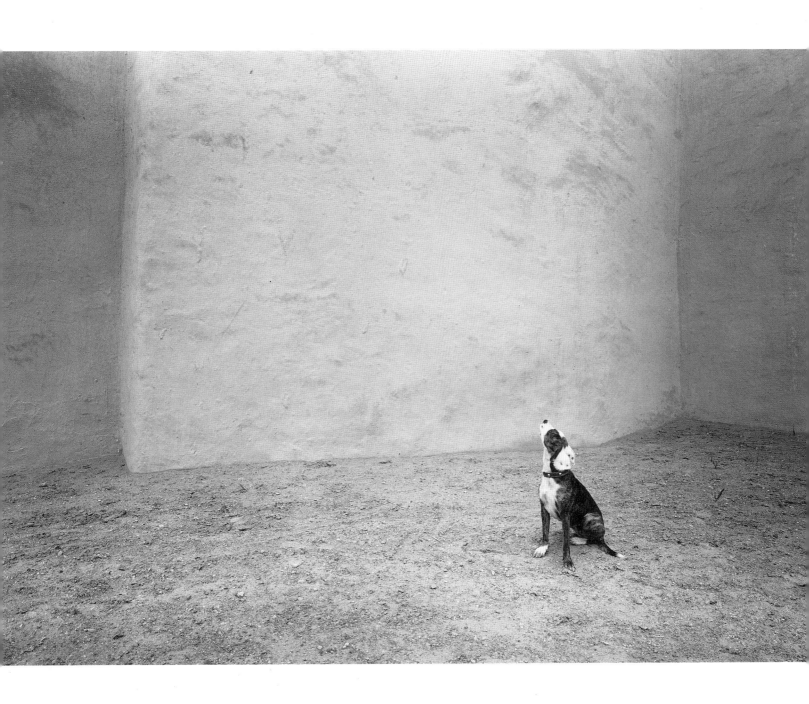

Many artists, photographers, and writers have tried to capture the ageless quality of the building's subtle lines and broad earthen planes. But to attempt this without also knowing the people and the open-sky land it serves is to miss the grandeur of its message. For the Church at Ranchos de Taos is all of this: a land, a people, and a faithful monument to their enduring heritage.

Wolfgang H. Pogzeba from *Ranchos de Taos— San Francisco de Asís Church*

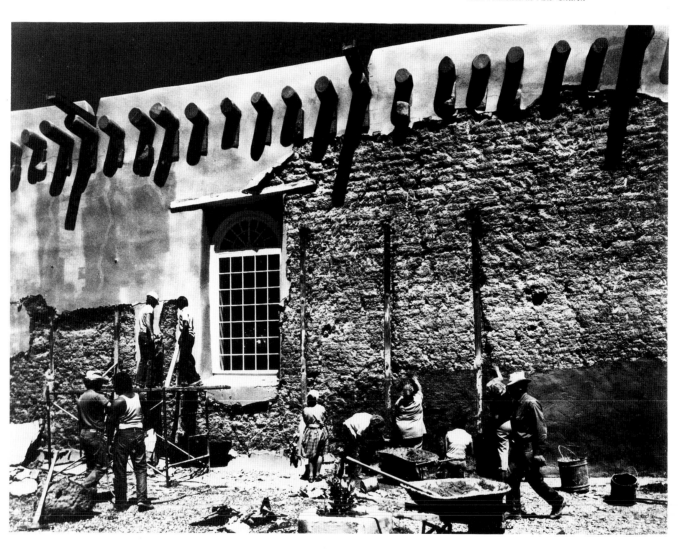

PLATE 65 (ABOVE)
Wolfgang H. Pogzeba
Untitled
1981

PLATE 66 (RIGHT)
William Acheff
Northern New Mexico, 1900
1981

98

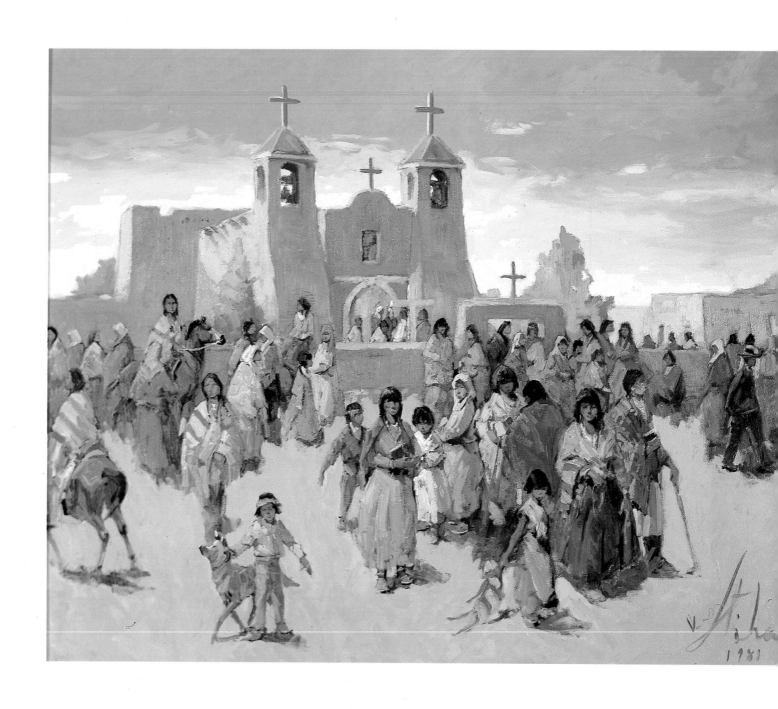

PLATE 67
Vladan Stiha
*Ranchos de Taos Church, St. Francis
de Asís*
1981

100

PLATE 68
Gary Niblett
Heavy Laden
1982

101

PLATE 69
Bill Buckley
San Francisco de Asís
1982

102

PLATE 70
Frederico Vigil
Encuentro en Ranchos
1982

PLATE 71 (TOP)
Michael Stack
Days Passing
1982

PLATE 72 (BOTTOM)
Paul Strisik
Ranchos de Taos
1982

104

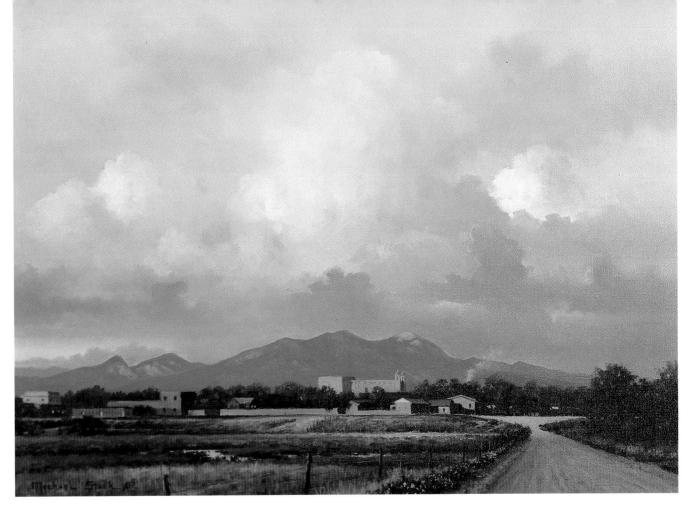

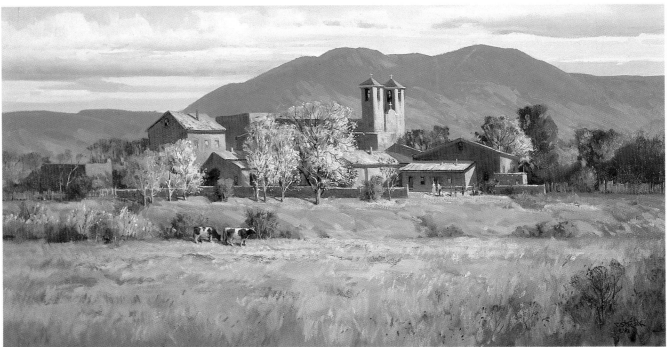

105

106

*. . . I have attempted to present the
church at Ranchos de Taos not primarily
as a work of art, but as a House of God.
It is a holy place, commanding an
awareness of the essential reality of which
the earth and all living things are a part.
In me it evokes emotional and aesthetic
responses like those expressed in the
joyous song of praise written by St.
Francis, for whom the church was named.*

Charles Van Maanen

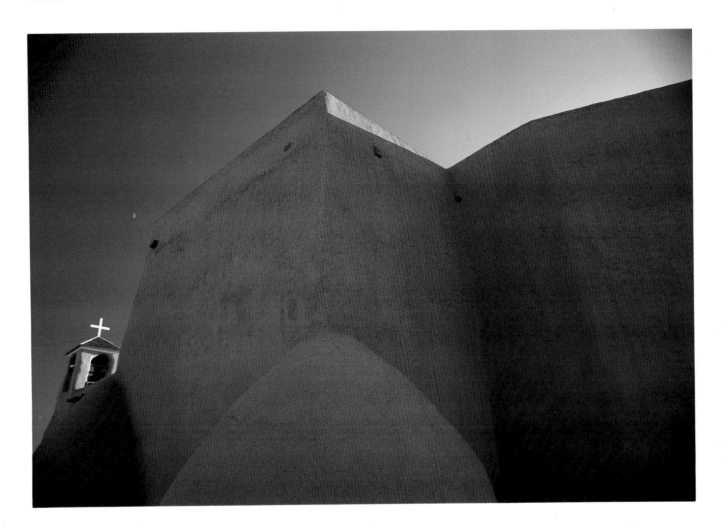

PLATE 75
Charles Van Maanen
Cross and Tower
1982

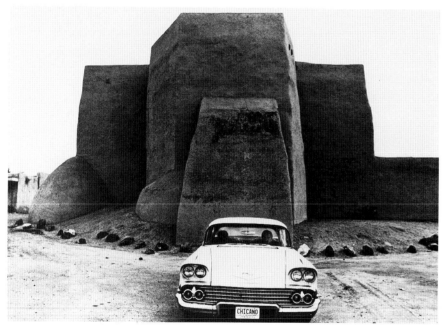

PLATE 76 (TOP)
Susan Zwinger
San Raphael Visits St. Francis
1982

PLATE 77 (BOTTOM)
Jim Shea
Untitled
1981

108

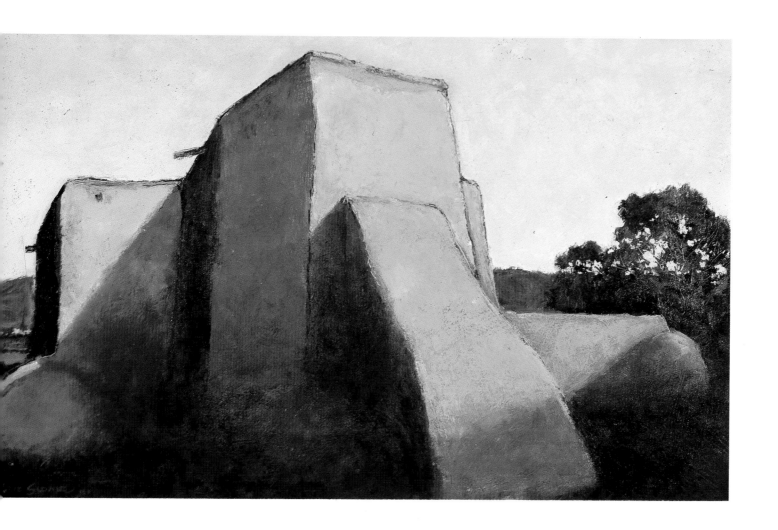

PLATE 78
Eric Sloane
The Mission at Ranchos
1982

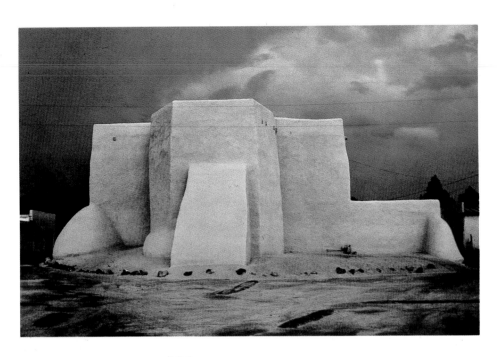

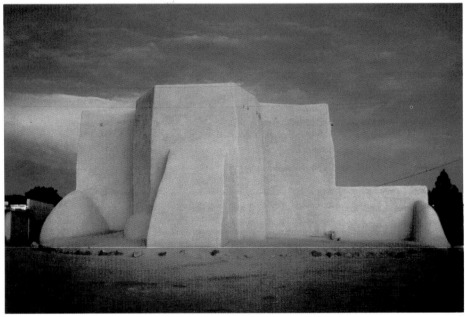

PLATE 79
Douglas Keats
Ranchos de Taos, I, II, III, IV
1984

110

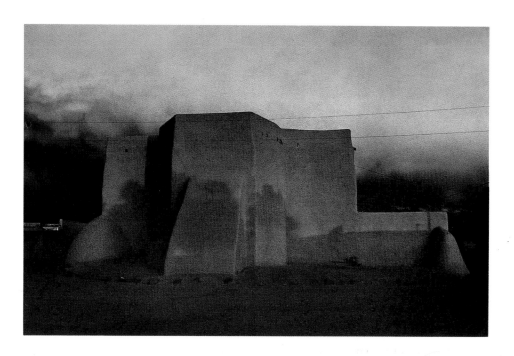

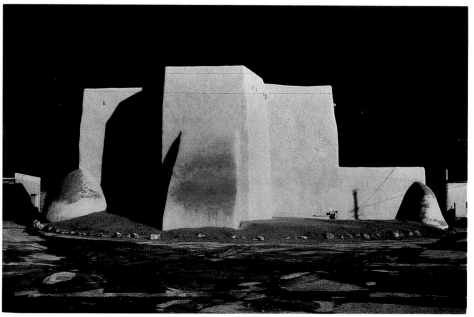

As viewers we accept the notion that the photograph accurately designates reality. However, by presenting multiple images of Ranchos, all taken from a similar perspective, the idea is reinforced that photography can render more than the single, authoritative view of reality. What photography actually describes is its own illusionistic view of the world. In fact, photographs can ascribe infinite variations to a single subject, each one as "real" as the next. Douglas Keats

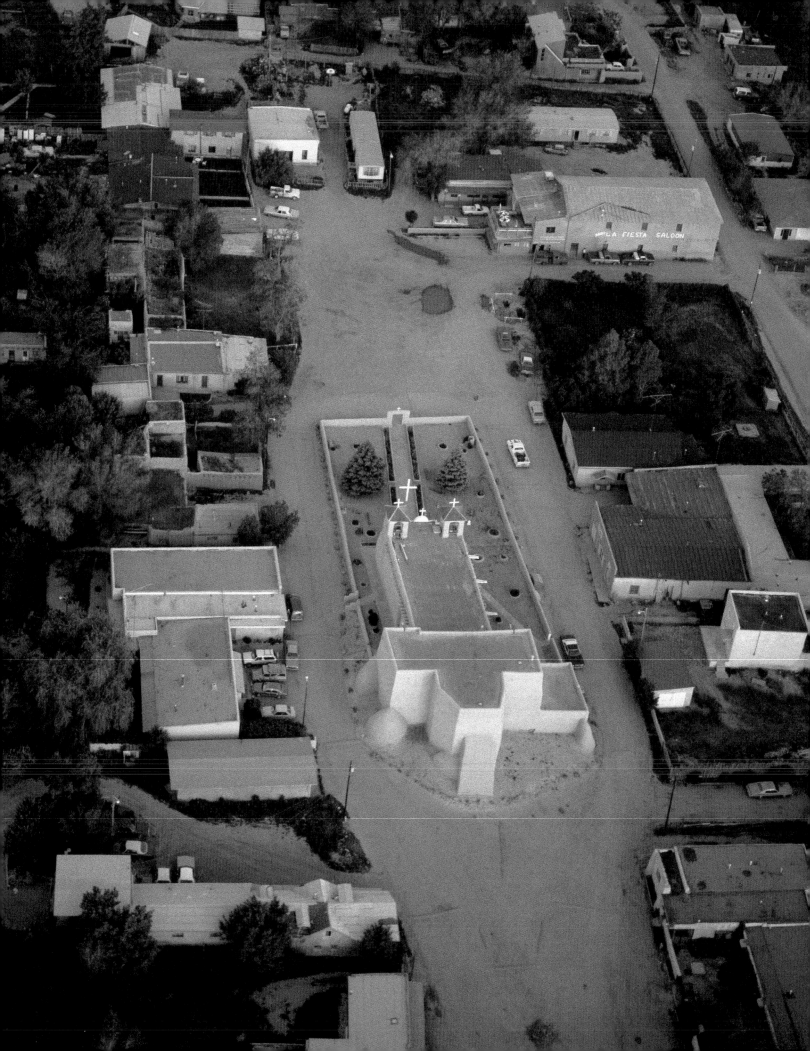

St. Francis of Assisi church and La Fiesta Saloon each have a claim on the plaza at Ranchos de Taos. It is obvious that the church does not stand alone, but is integral to the community. Though the church and the village are historical, this image adds the symbols of contemporary society. The saloon's umbrellas, the basketball goalpost, automobiles, and speed bumps speak of a living and vital community and church. These symbols will change, but the church will remain.
Paul Logsdon

PLATE 80
Paul Logsdon
Ranchos de Taos, St. Francis
1986

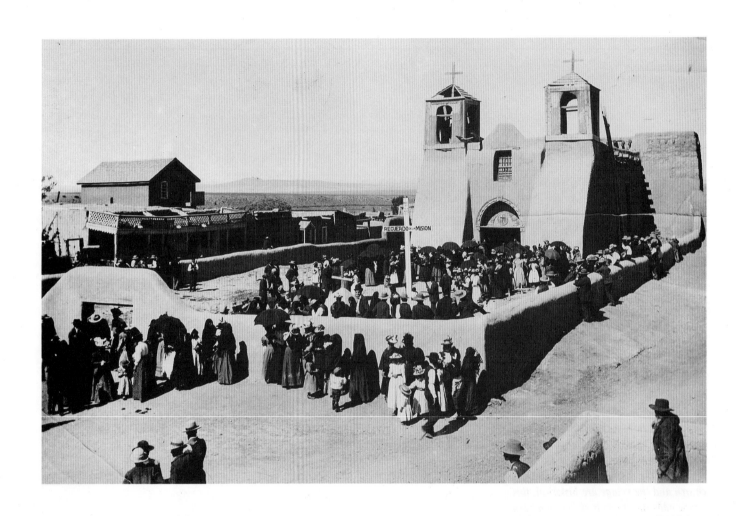

William Henry Jackson photographed in
northern New Mexico after 1881 and is
credited with having photographed the
Ranchos de Taos Church during that
time.

114

BORN OLD: THE CHURCH OF SAN FRANCISCO AT RANCHOS DE TAOS

John L. Kessell

Reviewing the year 1815, unstately, quizzical-looking James Madison, fourth president of the United States, could permit himself a hurrah on several counts: a solid victory at New Orleans, peace with the Barbary pirates, a resurgent confidence in the future of the Republic. Sulky Napoleon Bonaparte, whose hopes for Europe had soared again during the Hundred Days, stared at the floor on the island of St. Helena. And in Spain, Ferdinand VII absolutely trampled the liberal Constitution.

To the hearty common folk of San Francisco de las Trampas, alias El Rancho, in the high, lucid, gray-green valley of Taos, one of the most remote corners of the Spanish empire, the year 1815 was also memorable. At last they had a church.

There is no good evidence, archaeological or historical, of a church in use at Ranchos de Taos in the cañada of the Río Grande del Rancho (Río de las Trampas) before 1815. For hundreds of years, doubtless since before the arrival of the first non-Indians, two abiding characteristics of the site had dictated a recurrent cycle of settlement and abandonment: they were fertility and vulnerability.

Taos Indians, whose close-built pueblo stood eight miles to the north, had lived and planted in the area of Ranchos. Spaniards came permanently in the seventeenth century, spreading out along the slender, crystalline water courses in the valley, eventually to be massacred in the Pueblo Revolt of 1680. A generation later, others took their place. There are sketchy details of a short-lived mission for Jicarilla Apaches about 1733, perhaps in the cañada, but there is no mention of a church. In 1760 Bishop Pedro Tamarón, an observant traveler, took a midday break along the Río de las Trampas at the fortified house of a well-to-do Taos Indian, but he recorded no town and no church. He dwelt on the ferocity of raiding Comanches. Not even a fortified house would do.[1]

When the meticulous Fray Francisco Atanasio Domínguez came visiting in 1776, he found everyone in the valley,

1. Eleanor B. Adams, *Bishop Tamarón's Visitation of New Mexico, 1760* (Albuquerque: Historical Society of New Mexico, 1954), pp. 56–62; Dolores A. Gunnerson, *The Jicarilla Apaches, A Study in Survival* (DeKalb: Northern Illinois University Press, 1974), pp. 203–4, 212, who goes too far by equating Jicarilla "mission" with "church"; Myra Ellen Jenkins, "Taos Pueblo and Its Neighbors," *New Mexico Historical Review* 41 (1966):85–114.

Indian and non-Indian alike, lodged in Taos pueblo, which reminded him of "those walled cities with bastions and towers that are described to us in the Bible." Domínguez did mention a little settlement in the cañada of scattered ranchos called Trampas de Taos, whose patron since the mid-1760s, and perhaps earlier, had been San Francisco de Asís. In 1776, however, its settlers were living in the pueblo. "This does not mean that they will always live here," he was quick to add, "but only until completion of the plaza which by order of the aforesaid Knight Governor [Pedro Fermín de Mendinueta] is being built in the cañada where their ranchos are, so that living together in this way, even though they are isolated from the pueblo, they will be able to repel any attack the enemy might hurl at them."[2]

By 1779 the plaza was well along. Franciscan chronicler Juan Agustín de Morfi, writing secondhand in 1782, said that "the settlement forms a very spacious quadrilateral plaza, whose houses were almost finished in 1779, with several towers at regular distances for its defense." All the land, which he pointed out was even more fertile here than at the pueblo, belonged by rights to the Indians. Content to cultivate what they could, close to their dwellings, they left the rest to the Spaniards and charged no rent at all.[3] Neither Domínguez nor Morfi hinted at a church.

After 1786, when Governor Juan Bautista de Añza concluded a lasting peace with the Comanches, the Hispanic population of the Taos Valley exploded. The plaza of "Nuestro Padre San Francisco de las Trampas (alias Rancho)" grew apace. Judging by the entries in the baptismal, marriage, and burial books at the mission of San Jerónimo de Taos, particularly during the long tenure of Fray José de Vera (1794–1810), it was the largest settlement in the district. Still, it had no church. Father Vera performed these services for the people of El Rancho "in this church" at Taos pueblo.[4]

When was the Ranchos Church built? The question is simple, but the answers are many. Over the years there have been almost as many variant responses as beads on a rosary—in 1710 or 1718, from alleged dating on beams; in 1732 or 1733, from the tentative missionary overture to local Jicarilla Apaches; in 1772, "the understanding among those best informed" (1915);[5] in the later 1770s or about 1780, from references to laying up the defensive plaza of San Francisco de las Trampas at El Rancho. Until recently, for lack of documentation, it was anybody's guess.

Now, however, thanks to a thin file of original documents that several years ago found its way into the Archives of the Archdiocese of Santa Fe, a single, almost unqualified

2. Eleanor B. Adams and Fray Angelico Chavez, *The Missions of New Mexico, 1776: A Description by Fray Francisco Atanasio Domínguez with Other Contemporary Documents* (Albuquerque: University of New Mexico Press, 1956, 1975), p. 110, 112–13; Biblioteca Nacional, México, New Mexico Documents, legajo 10, no. 43; William Wroth, *The Chapel of Our Lady of Talpa* (Colorado Springs; The Taylor Museum, 1979), pp. 16–18.

3. Fray Juan Agustín de Morfi, "Geographical Description of New Mexico," in Alfred Barnaby Thomas, *Forgotten Frontiers: A Study of the Spanish Indian Policy of Don Juan Bautista de Anza, Governor of New Mexico, 1777–1787* (Norman: University of Oklahoma Press, 1932, 1969), pp. 96–97; Archivo General de la Nación, México, Historia, 25, fol. 101v–102.

4. Archives of the Archdiocese of Santa Fe, Albuquerque (AASF), B-46, Taos (Box 69), 1777–98; B-38, Taos (Box 70), 1799–1826; M-37, Taos (Box 35), 1777–1822. If there was a private chapel somewhere in the Ranchos area before 1815, no record of it has yet come to light.

5. L. Bradford Prince, *Spanish Mission Churches of New Mexico* (Cedar Rapids: The Torch Press, 1915), p. 261.

6. AASF, General, Historical, Ranchos Church. Historians have already begun to take note of these documents— the 1813 license to build the chapel, several inventories, and related items—and to close on the year 1815. See, for example, Fray Angelico Chavez, *But Time and Chance: The Story of Padre Martínez of Taos, 1793–1867* (Santa Fe: Sunstone Press, 1981), pp. 20, 28; Wroth, *Chapel of Our Lady of Talpa*, pp. 22, 23, 41 n.2; and John L. Kessell, *The Missions of New Mexico Since 1766* (Albuquerque: University of New Mexico Press, 1980), pp. 109, 114 n.4.

7. On Pereyro, whose tenure as custos lasted from September 1808 to September 1811, see AASF, 1815, no. 3, and Kessell, *Missions*, p. 240. Strained relations with his Franciscan brethren are evident in documents calendared by Chavez in *Archives of the Archdiocese of Santa Fe, 1678–1900* (Washington, D.C.: Academy of American Franciscan History, 1957).

8. Fray José Benito Pereyro, Noticias de las misiones, Santa Fe, Dec. 31, 1810, Huntington Library, San Marino, William G. Ritch Col.

9. The diocesan decree is mentioned in the actual license to build the chapel. Francisco Fernández Valentín, Durango, Sept. 20, 1813, AASF, Ranchos Church.

10. Fray Antonio Caballero, Cochití, Sept. 22, 1812, ibid.

11. Reference to the endorsements of alcalde mayor, governor, and commandant general are found in the license, Sept. 20, 1813, ibid.

12. During the visitation by don Juan Bautista Ladrón de Guevara, Taos, June 10–13, 1818, scribe Francisco Pérez Serrano copied the date of the license incorrectly, making it September 20, 1803. ASSF, Books of Accounts, LXII, Santa Fe (Box 5), fol. 102. Chavez, *Archives*, p. 190, reported that date, and E. Boyd, *Popular Arts of Spanish New Mexico* (Santa Fe: Museum of New Mexico Press, 1974), p. 352, followed. There was no 1803 license. (The same scribe copied the date correctly in the notice appended to the license itself.)

answer is possible.[6] The chronology, it appears, unfolds like this.

Summer, 1810. Probably, as much as anything, to get as far away from some of his fellow friars as he can, a preoccupied forty-two-year-old Fray José Benito Pereyro, *custos*, or superior, of the Franciscans of New Mexico, moves from Santa Clara pueblo to Taos. A Spaniard from the town of San Salvador de Arnoya on the Río Miño in Galicia, Pereyro has served in New Mexico for more than sixteen years.[7] Now, as missionary pastor of San Jerónimo de Taos, he has spiritual responsibility, according to his own year-end count, for 537 Indians and 1,267 "Spaniards and people of all classes."[8] Many of the latter, he is aware, live down the valley, three leagues southwest, at a place long known as El Rancho de Taos in the plaza de San Francisco de las Trampas, not to be confused with the other Las Trampas in the jurisdiction of neighboring Picurís.

By the spring of 1812, after he has laid down the burdens of superior, Father Pereyro discusses with leading citizens of San Francisco de las Trampas the license they want for a church of their own. They listen. Evidently in response to a query from them, a decree describing the procedure goes out from the diocesan office in Durango, eleven hundred miles south. It is dated August 4, 1812.[9] They must first document the need for such a chapel. They must get the certification of local authorities.

Fray Antonio Caballero, Pereyro's successor as custos, replies promptly on September 22. He declares that a chapel at the Plaza of San Francisco, more than three leagues from its priest, would be most convenient, and that the settlement is populous enough "to maintain its chapel in all cleanliness with everything necessary for public worship."[10] That same day, it seems, the *alcalde mayor*, or district officer, of Taos endorses the project. For some reason interim Governor José Manrique takes until the following March 20 to respond. Finally, when Commandant General Nemesio Salcedo, as vice patron of the church in the Provincias Internas, gives his approval in Chihuahua on April 23, 1813, the way is clear for the diocese of Durango to issue the awaited license.[11]

It bears the date September 20, 1813.[12] Because the see of Durango is vacant at the time, the canon, Dr. Francisco Fernández Valentín, acting in a bishop's stead, signs the instrument. Inasmuch as Juan de la Cruz Vigil for himself and all the other residents of San Francisco de las Trampas has stated and properly documented the need to build a chapel,

> we do grant and concede our permission and license in order that in the above-mentioned settlement of Las Trampas the stated chapel may be founded, erected, constructed, and built, and dedicated to its titular saint, on the necessary condition that

said citizens are responsible for providing whatever repairs it may require for its preservation, and for maintaining it in cleanliness, with vestments, sacred vessels, and the other utensils appertaining to the worship of Our Lord and God.

The license grants to the priest to whom the settlement belongs authority to inspect the chapel upon completion and, if it is fully furnished, cleanly, and meets the other requisites, all of which he is to record duly,

he might bless it as and in the form that the Roman Ritual prescribes. Once it is blessed, the Holy Sacrifice of the Mass may be celebrated in it every day of the year and the other Sacraments and Spiritual Nourishment administered (with the expressed previous permission of the Parish Priest to whom it pertains, and in no other way) by whatsoever Priest, Secular or Regular, examined and approved in this Diocese.[13]

Given the long road from Durango to Taos, it is not likely that the license dated September 20 reaches the eager citizens of San Francisco de las Trampas until well after the first hard frost, probably not until November. It is too late to begin construction.

With the coming of spring in 1814, Vigil and his neighbors launch the monumental community project with gusto and, crops and trade permitting, keep at it until the cold weather dictates a halt. Interior or detail work may occupy them through the winter. By the summer of 1815 an end is in sight. Some shout. Others surely weep.

July 13, 1815. The time has come to draw up a formal petition to the Franciscan superior, asking for the services of Father Pereyro. Before, they had gone to the padre at Taos pueblo, bearing their babies for baptism and their dead for burial. Now, with their new church ready or almost ready, they are asking that he come to them.

Don Ignacio Durán, who contributed the carved double front doors and, with Father Pereyro, the main altarpeice and the pulpit, and who may have been the first sacristan, writes the request in his large, studied hand. For all the citizens of the plaza of San Francisco de las Trampas, he asks that Father Pereyro be permitted to minister to them and to the people of the nearby plaza of San Francisco de Padua (Lower Ranchitos). In compliance with a royal order, they obligate themselves to pay for his services with provisions—the well-off, two *fanegas* (about five bushels) of grain, and the poor, one fanega.[14]

So far, 1815 has been quite a year for Father Pereyro. Back in April the Taos Indians had appealed to him to help them move the non-Indian settlers off the Taos pueblo grant.

13. The 1813 license further authorized the minister of Taos to celebrate on all holy days a second mass, "one in his parish church and another in the new chapel that is to be built." AASF, Ranchos Church.
14. Ignacio Durán to Fray Isidoro de Barcenilla, Taos, July 13, 1815, AASF, 1815, no. 21. The response has not turned up. According to its title, the earliest inventory in AASF, Ranchos Church, dated October 29, 1817, corrected two errors in the receipt given to Ignacio Durán. On that date everything was in the possession of Juan Lovato, the succeeding sacristan, because the chest in the sacristy had no key.

Tempers flared. The priest and Alcalde Mayor Pedro Martín, who would donate a set of vestments and some money to the new church at El Rancho de Taos, feared violence if more than two hundred families were ordered off the land and put out of their homes.[15] Well south of the disputed zone, workers at the plaza of San Francisco de las Trampas at El Rancho must have breathed easier when the parties reached a compromise. In May and June there had been "Frenchmen" in Taos. They had soon left for Louisiana.

Then in August there is talk that the tithe collector, Pedro Martín, would be asking for more this year. How in the world did the government think the poor colonists of New Mexico could pay an extra five percent to help fight insurgents in the south? On August 14, three licensed parties set out from the valley: Taos Indians bound for La Casa de los Cíbolos, José Vigil with twenty men to trade among the Comanches, and another twenty going to the Kiowa Apaches.[16]

On September 17, 1815, Alcalde-Tithe Collector Martín reports to Santa Fe an incident that had sent a shudder of fright up and down the valley. Thirty Comanches had ridden in looking for Jicarilla Apaches. Learning that a Jicarilla couple was staying with an Indian of Taos pueblo, they had simply entered, killed the man, and abducted the woman. Visiting Comanches and other Indians were always told that they must not kill anyone "among us," Martín apologizes, "but their hatred is so great that they cannot contain themselves."[17]

At the same time, the wars in Europe intrude. Word reaches Santa Fe that the "vile adventurer" Napoleon, "the monster of Corsica," has again usurped the French throne and that all Europe is uniting to oppose him. The peoples of America, meantime, must be on their guard against his wily agents and emissaries.[18] A peninsular Spaniard, Father Pereyro leads his parishioners in the required "loyalty oath to our beloved Ferdinand VII, detesting insurgents and their followers."[19]

It is tempting to conjure up a festive blessing of the Church of San Francisco de Asís on the day of St. Francis, October 4, 1815, but there is at present no direct documentary evidence to prove it. Father Pereyro did write to the diocesan office in Durango, apparently about this time, asking for permission to bury inside the new "chapel," a sure sign that it had already been blessed. The date of the response, signed at Durango on January 9, 1816, minus the time Father Pereyro's request had been in the mail (five or six weeks at the least) and in the process (perhaps as long), implies a fall blessing.[20]

An 1818 note added to the earliest extant Ranchos Church inventory, dated October 29, 1817, proclaims that "This

15. Pereyro and Martín to Gov. Alberto Maynez, Taos, May 13, 1815, Spanish Archives of New Mexico, State Archives and Record Center, Santa Fe (SANM), Series II, no. 2596. Proceedings in the 1815 dispute, in SANM, Series I, no. 1357, are reviewed by Jenkins, "Taos Pueblo and Its Neighbors": 100–3. The church mentioned in the documents must have been Nuestra Señora de Guadalupe at the plaza of Don Fernando de Taos.
16. Pablo Lucero to Maynez, Taos, Aug. 10 and 16, 1815, SANM, II, nos. 2617 and 2621. Diario, Santa Fe; Dec. 31, 1815, SANM, II, no. 2585.
17. Diario, Santa Fe, Dec. 31, 1815, SANM, II, no. 2585.
18. Miguel Lardizábal y Uribe to comandante general, Madrid, Apr. 29, 1815, copy, Durango, Aug. 19, 1815, SANM, II, no. 2594.
19. Certification, Pereyro, Taos, Sept. 23, 1815, AASF, no. 29. See also ibid., no. 18.
20. Although the January 9, 1816, permission is not among the documents in AASF, Ranchos Church, it is mentioned in two notices of the 1818 Guevara visitation, one ibid., and one in AASF, Accounts, LXII, Santa Fe (Box 5), fol. 102. There is a chance that Pereyro's request, informing the diocesan office of the chapel's completion, might be found in the Cathedral Archive, Durango.

temple was constructed at the expense of the Rev. Father Minister Fray José Benito Pereyro and the citizenry of this Plaza."[21] If the documents called it a *capilla*, or chapel, it was not because of the building's less-than-churchly proportions, but rather because of its dependency on the mission parish of San Jerónimo de Taos, where the pastor lived.

In fact, the Ranchos Church was just as big. San Jerónimo at Taos pueblo, which dated from 1726, may have been a few varas longer, but it was one vara (2¾ feet) narrower and it lacked the transept of the new structure. According to rough dimensions in an 1831 Ranchos inventory, the nave of the thick-walled, cruciform adobe temple of San Francisco de Asís measured thirty-one varas long by nine wide by nine high (85¼ × 24¾ × 24¾ feet) inside, not counting the narthex under the choir loft, the arms of the transept, or the apse. The

21. AASF, Ranchos Church. Pereyro, who might have helped date the new church he blessed at El Rancho by specifying where in his parish he performed the sacraments, failed to do so, for which he was posthumously criticized in 1818. On May 27 of that year, just three days after Pereyro's death, an interim successor recorded routinely a burial "en la Capilla del Rancho." AASF, B-38, Taos (Box 70), 1799–1826.

U.S. *Dept. of Interior plot plans dated 30 March 1934.*

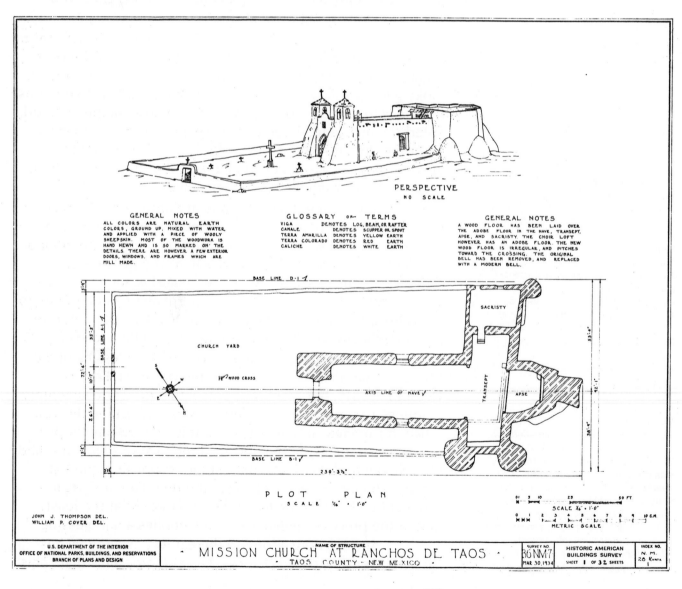

120

22. Inventario, San Francisco del Rancho, Feb. 18, 1831, AASF, Ranchos Church. The nave's dimensions, 31 × 9 × 9 varas, are repeated in a June 1, 1856, inventory (ibid.), and, when allowance is made for narthex, transept, and apse, fit neatly the measured architectural drawings made in 1934 by the Historic American Buildings Survey (HABS, Mission Church at Ranchos de Taos, Survey No. 36-NM-7, 32 sheets). Between 1831 and 1856, however, the walled cemetery grew from 22 × 19 varas to 40 × 22 varas (110 × 60½ feet), still with two gates, one in front and one on the side. The size of the mother church of San Jerónimo de Taos is taken from Adams and Chavez, *Missions*, p. 102.

builders had raised the walls of the transept and apse higher than those of the nave, and they had installed a transverse clerestory window, that most characteristic feature of colonial New Mexico church architecture. Above the facade, breaking the flat roof line, they erected two little cubelike bell towers—*torrecitas*, the inventory called them. The walled cemetery out front, with its two gates, was twenty-two varas (60½ feet) long and nineteen (52¼ feet) across.[22]

The 1817 inventory gives a pretty fair picture of what the initial adornment was like inside: "Said Rev. Father [Pereyro] and don Ignacio Durán, and the citizens had built at their cost the [main] altarpiece and had it painted using scaffolding." It is still in place. A roughly three-hundred-square-foot backing on which to hang religious art, it features hand-carved moldings and twisted columns fastened to the panels

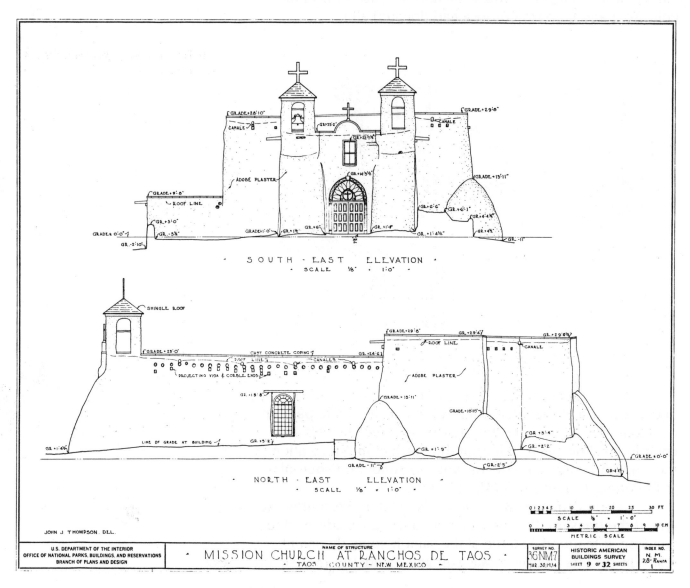

SOUTH · EAST · ELEVATION
· SCALE ⅛" = 1'·0" ·

NORTH · EAST · ELEVATION
· SCALE ⅛" = 1'·0" ·

JOHN J. THOMPSON DEL.

| U.S. DEPARTMENT OF THE INTERIOR
OFFICE OF NATIONAL PARKS, BUILDINGS, AND RESERVATIONS
BRANCH OF PLANS AND DESIGN | NAME OF STRUCTURE
· MISSION CHURCH AT RANCHOS DE TAOS ·
· TAOS · COUNTY · NEW MEXICO · | SURVEY NO.
36 NM 7
MAR. 30,14,34 | HISTORIC AMERICAN
BUILDINGS SURVEY
SHEET 9 OF 32 SHEETS | INDEX NO.
N. M.
28· Rancha 1 |

with wooden pegs. The parish household also had given the statue of San Francisco de Asís which stood in its niche of honor, and the wooden altar table, altar steps, and altar rail. (A tabernacle and the eight paintings on canvas "brought from outside" showed up first on the 1831 inventory during the tenure of the famed padre of Taos, Antonio José Martínez.)

To the right in the northeast arm of the transept, then as now, stood an even larger altarpiece built and painted at the expense of don "Carpio" Córdova, who paid as well for the statues of Nuestro Señor de Esquípulas and two other saints who shared his niche and for wooden altar table, steps, and rail. (The more detailed 1831 list mentioned eight images painted on the altar screen and, surmounting them, the Dove, "symbol of the Holy Spirit," now missing. And it identified the other two bultos as Nuestra Señora de los Dolores and Santa Ludovina. Two large and two small mirrors graced the altar. Policarpio and Lorenzo Córdova had donated all.)

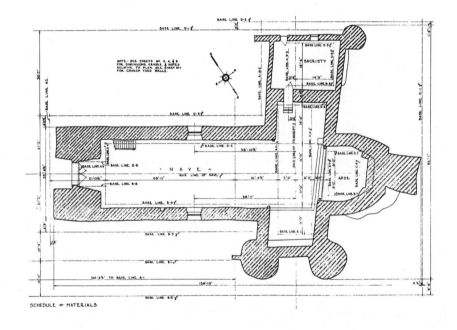

U.S. Dept. of Interior floor plans dated 30 March 1934.

This side altar devoted to Nuestro Señor de Esquípulas and attributed to the artist called variously the "chile painter" or "Molleno" offers supporting evidence of the church's 1815 completion. The same craftsman did much of the decoration in the contemporary Santuario de Nuestro Señor de Esquípulas at El Potrero (Chimayó), finished in 1816.

Don Francisco Martín gave the altar in the southwest arm of the transept. It vanished some time ago. Dedicated to San José, it featured a statue of the saint holding the infant Jesus. In 1817 its altarpiece was still unpainted. (By 1831 seven

23. AASF, Ranchos Church. Boyd, *Popular Arts*, pp. 349–65, discusses Molleno and his work, as does Stephen F. de Borhegyi, "The Miraculous Shrines of Our Lord of Esquípulas in Guatemala and Chimayo, New Mexico," *El Palacio* 60 (1953): 83–111. On July [June?] 30, 1815, Father Pereyro baptized four-day-old Manuel de Esquípulas, son of Jesús Sandoval and Petrona Lovato, but, as was his frustrating custom, he did not say where he performed the sacrament. AASF, B-38, Taos (Box 70), 1799–1826. See also E. Boyd, "Museum Conservation Project at Ranchos de Taos," *El Palacio* 60 (1953): 414–18; and Wroth, *Chapel of Our Lady of Talpa*, p. 27, 42 n.11, and *Christian Images in Hispanic New Mexico: The Taylor Museum Collection of Santos* (Colorado Springs: The Taylor Museum, 1982), pp. 93–103. It may be that the San José altarpiece found its way to the Denver Art Museum.

24. Rio Grande Tree-Ring Sample Catalog Book 1, Laboratory of Tree-Ring Research, University of Arizona, Tucson: W. S. Stallings, Jr., "Southwestern Dated Ruins: I," *Tree-Ring Bulletin* 4, no. 2 (Oct. 1937): 5, dated the Ranchos samples 1816, give or take ten years. More recently, William J. Robinson and Richard L. Warren, *Tree-Ring Dates from New Mexico C–D, Northern Rio Grande Area* (Tucson: Laboratory of Tree-Ring Research, 1971), p. 41, have assigned tentative dates of 1776, 1808, and 1808 (with "no way of estimating how far the last ring is from the true outside"), and 1808 (apparently "within a very few years of being a cutting date"). "The cluster at A.D. 1808," they conclude, "although not cutting dates, strongly suggests major construction not long after that date."

For aid and comment, I should like to thank Sister Loyola Maestas, Archivist of the Archdiocese of Santa Fe; Christine Mather, former Curator of Spanish Colonial Collections at the Museum of International Folk Art, Santa Fe; William Wroth, formerly of The Taylor Museum, Colorado Springs; Richard E. Ahlborn, Curator, Division of Community Life, Smithsonian Institution; and Corina Santistevan of the Ranchos parish.

painted images attended the statue in its niche and a tabernacle rested on the adobe altar table.) Through a door to the left of this altar one entered the sacristy with its ample but lockless chest for the vestments. (A listing of items acquired between 1826 and 1829 included a lock and key for the chest, the gift of mountain man Thomas Boggs.)

At the crossing stood pulpit and confessional. (Pulpit and sounding board, said the 1831 inventory, were oil painted, and a coffin lay nearby.) The people had paid to have one bell made (in another hand, presumably somewhat later, someone added "with new clapper"). Although not itemized on the 1817 list, which was limited to furnishings, certain architectural features mentioned in 1831 and 1856 inventories must surely have been details of original construction—the choir loft immediately above the main entrance, with its railing and ladder; the two high wood-framed windows in either side wall of the nave; and the twenty-six-pane transverse clerestory that let morning light fall on crossing and altar.[23]

Often the wooden parts of an adobe structure can help date its construction. In the fall of 1933 the Ranchos Church was reroofed. Four tree-ring samples taken by members of the Historic American Buildings Survey from beams lying on the ground but "originally in either chancel or transept," although not precisely datable, in no way disallow construction in 1814–15.[24]

From either brow of the cañada, but especially from the southwest, the church of San Francisco de Asís at Ranchos de Taos stood out proudly above the hollow rectangle of lower earthen buildings that enclosed it. That it was finished in 1815, during the time of James Madison, Napoleon, and Ferdinand VII—and not in 1710, during the time of Cotton Mather, Louis XIV, and Philip V—robs it of none of its beauty. It is no less a lasting monument to the love and devotion and hard work of the people of Ranchos who built it. It is still the essence of religious architecture in New Mexico. It is still as picturesque, still as photogenic.

And there is one advantage. None of us has missed its bicentennial.

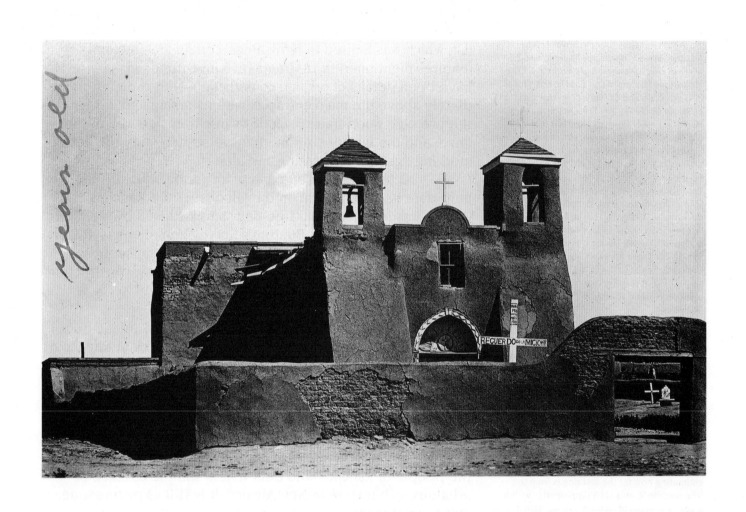

A view of the church made after 1881,
attributed to William Henry Jackson.

124

SUGGESTED READING

Adams, Eleanor B. *Bishop Tamaron's Visitation of New Mexico, 1760.* Albuquerque: Historical Society of New Mexico, 1954.

Adams, Eleanor B., and Chavez, Fray Angelico. *The Missions of New Mexico, 1776: A Description by Fray Francisco Alanasio Dominguez with Other Contemporary Documents.* Albuquerque: University of New Mexico Press, 1956, 1975.

Bickerstaff, Laura M. *Pioneer Artists of Taos.* Denver: Sage Books, 1955. Revised edition, Denver: Old West Publishing Co., 1983.

Blumenschein, Ernest. "The Broken Wagon Wheel: Symbol of Taos Art Colony." *Santa Fe New Mexican* (1939).

Borhegyi, Stephen F. de. "The Miraculous Shrines of Our Lord of Esquipulas in Guatemala and Chimayo, New Mexico." *El Palacio* 60 (1953).

Boyd, E. "Museum Conservation Project at Ranchos de Taos." *El Palacio* 60 (1953).

Boyd, E. *Popular Arts of Spanish New Mexico.* Santa Fe: Museum of New Mexico Press, 1974.

Broder, Patricia Janis. *Taos: A Painter's Dream.* Boston: New York Graphic Society, 1980.

Chavez, Fray Angelico. *But Time and Chance: The Story of Padre Martinez of Taos, 1793–1867.* Santa Fe: Sunstone Press, 1981.

Coke, Van Deren. *Taos and Santa Fe: The Artist's Environment, 1882–1942.* Albuquerque: University of New Mexico Press, 1963.

Cortright, Barbara. "Fritz Scholder." *Artspace* (Summer, 1983).

Eldredge, Charles C.; Schimmel, Julie; and Treuttner, William H. *Art in New Mexico, 1900–1945: Paths to Taos and Santa Fe.* New York: Abbeville Press and Washington, D.C.: National Museum of American Art, Smithsonian Institution, 1986.

Fleck, Joseph, Jr. "Joseph A. Fleck, Sr.—A Fine Sense of Poetry." *Southwest Art* (January, 1981).

Gunnerson, Dolores A. *The Jicarilla Apaches: A Study in Survival.* DeKalb: Northern Illinois University Press, 1974.

Hassrick, Peter. *The Way West: Art of Frontier America.* New York: Harry N. Abrams, Inc., 1972.

Historic American Buildings Survey. HABS, Mission Church at Ranchos de Taos. Survey No. 36–NM–7, 32 sheets. Library of Congress.

Hunt, David C., and Rossi, Paul A. *The Art of the Old West.* New York: Alfred A. Knopf, 1971.

Jenkins, Myra Ellen. "Taos Pueblo and Its Neighbors." *New Mexico Historical Review* 41 (1966).

Kessell, John L. *The Missions of New Mexico Since 1766.* Albuquerque: University of New Mexico Press, 1980.

Luhan, Mabel Dodge. *Movers and Shakers.* New York: Harcourt, Brace & Co., 1936. New edition, Albuquerque: University of New Mexico Press, 1985.

Nelson, Mary Carroll. *The Legendary Artists of Taos.* New York: Watson-Guptill Publications, 1980.

O'Keeffe, Georgia. *Georgia O'Keeffe.* New York: Viking Press, 1976.

Prince, L. Bradford. *Spanish Mission Churches of New Mexico.* Cedar Rapids: The Torch Press, 1915.

Robertson, Edna, and Nestor, Sarah. *Artists of the Canyons and Caminos.* Utah: Peregrine Smith, 1976.

Rubin, William, ed. *"Primitivism" in 20th Century Art—Affinity of the Tribal and the Modern.* New York: Museum of Modern Art, 1984.

Thomas, Alfred Barnaby. *Forgotten Frontiers: A Study of the Spanish Indian Policy of Don Juan Bautista de Anza, Governor of New Mexico, 1777–1787.* Norman: University of Oklahoma Press, 1932.

Tompkins, Calvin. *Sixty Years of Photographs.* Aperture Monograph Series. Millerton: Aperture, Inc., 1976.

Udall, Sharyn Rohlfsen. *Modernist Painting in New Mexico 1913–1935.* Albuquerque: University of New Mexico Press, 1984.

Vierra, Carlos. "New Mexico Architecture." *Art and Archaeology* (January/February, 1918).

White, Robert R., ed. *The Taos Society of Artists.* Albuquerque: University of New Mexico Press, 1983.

Wroth, William. *The Chapel of Our Lady of Talpa.* Colorado Springs: The Taylor Museum, 1979.

Wroth, William. *Christian Images in Hispanic New Mexico: The Taylor Museum Collection of Santos.* Colorado Springs: The Taylor Museum, 1982.

Photographs on pages x and xii by Vicente M. Martinez (1940–) are from the collection of San Francisco de Asís Church. The following photographs are courtesy of the Museum of New Mexico Photo Archives: Pg. xvi, Neg. No. 40377; Pg. 5, Neg. No. 16755; Pg. 6, Neg. No. 89935; Pg. 11 by T. Harmon Parkhurst, Neg. No. 73938; Pg. 12, Neg. No. 59740; Pg. 13, Neg. No. 16755; Pg. 14, Neg. No. 50822; Pg. 15, Neg. No. 9763; Pg. 22, Neg. No. 20787. The following photographs are courtesy of the Colorado Historical Society: Pg. 114 and Pg. 124. Photograph by Ansel Adams, Pg. 40, courtesy of the Trustees of the Ansel Adams Publishing Rights Trust. All rights reserved. Excerpt on Pg. 42 from *Georgia O'Keeffe*, by Georgia O'Keeffe. A Viking Studio Book. Reprinted by permission of The Viking Press. Excerpt Pg. 88 from *Instante y Revelation*, by Octavio Paz and Manuel Alvarez Bravo. A Circulo Editorial publication, Mexico, D.F.

INDEX OF ARTISTS